When Elvis Presley walked onstage in 1956, time stopped—
and then exploded. The earth shook on its axis and the
beat of everyday life was jolted. In an instant, mainstream
America's culture of complacency evaporated.

Elvis, at the flashpoint of his fame.

Alfred Wertheimer's photographs document this moment.
The images are a national treasure—a unique visual record of
one of the most exciting performers of his time, one of the
most influential of all time, the first true icon of rock 'n' roll.

1956 marked a turning point in America. Momentum for
change had begun to shift from the edges to the center of the
mainstream. In popular music, Elvis created an integrating
synthesis of rhythm and blues, gospel, and country that
bridged white and black, urban and rural. His words and
music gave voice to a new version of the American dream.

Elvis launched a cultural revolution, and Alfred Wertheimer
captured its transit.

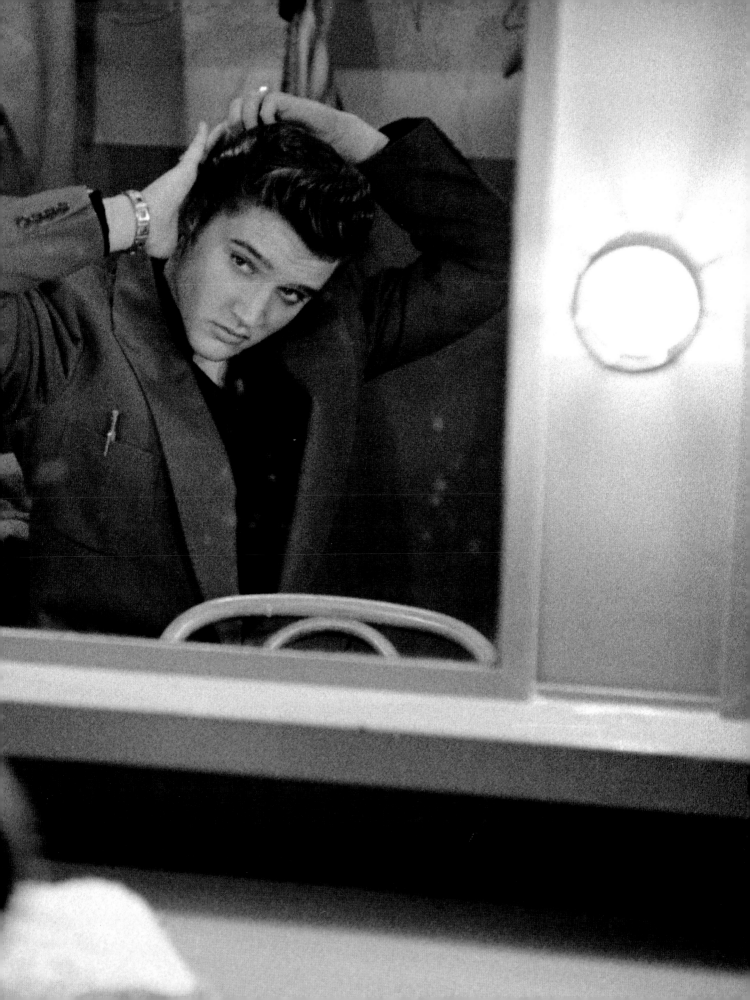

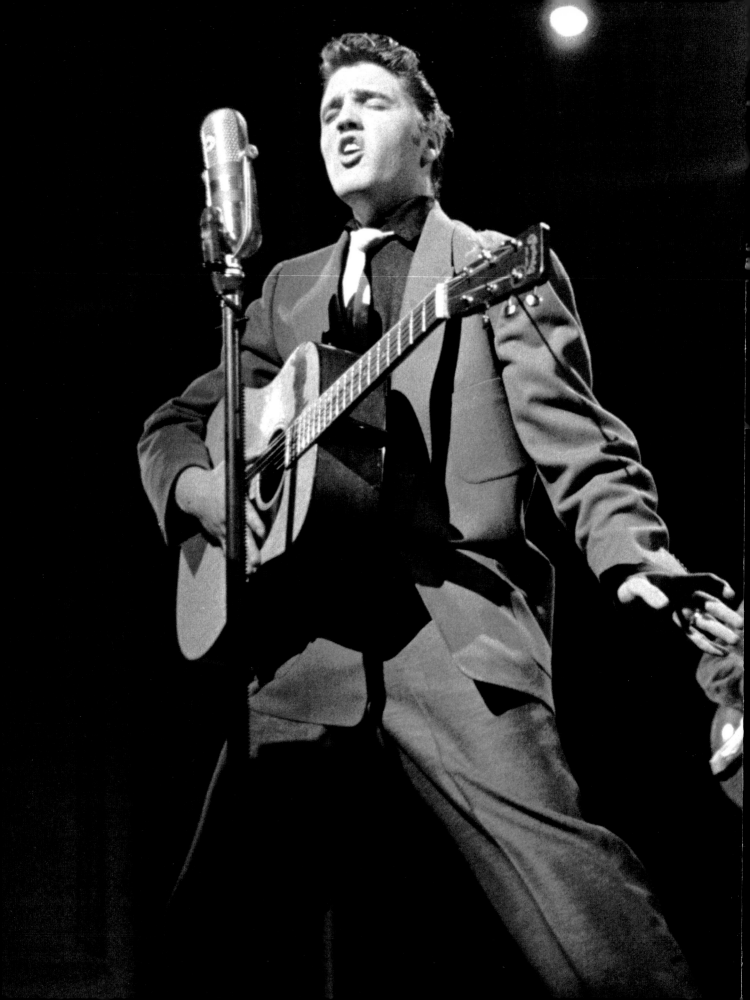

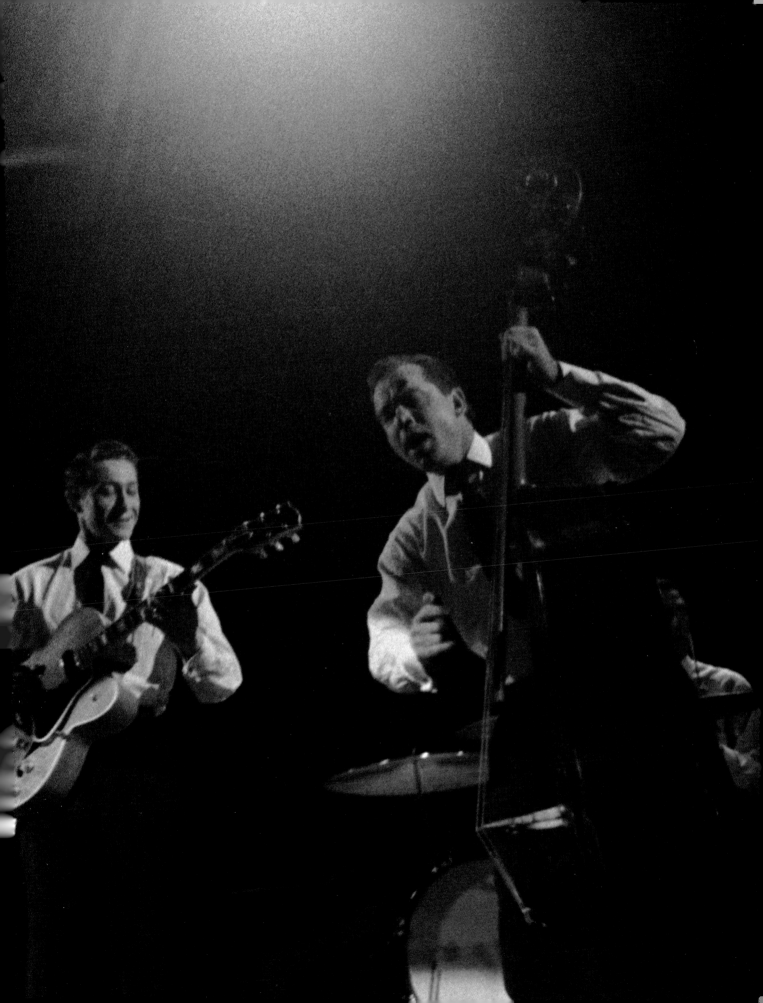

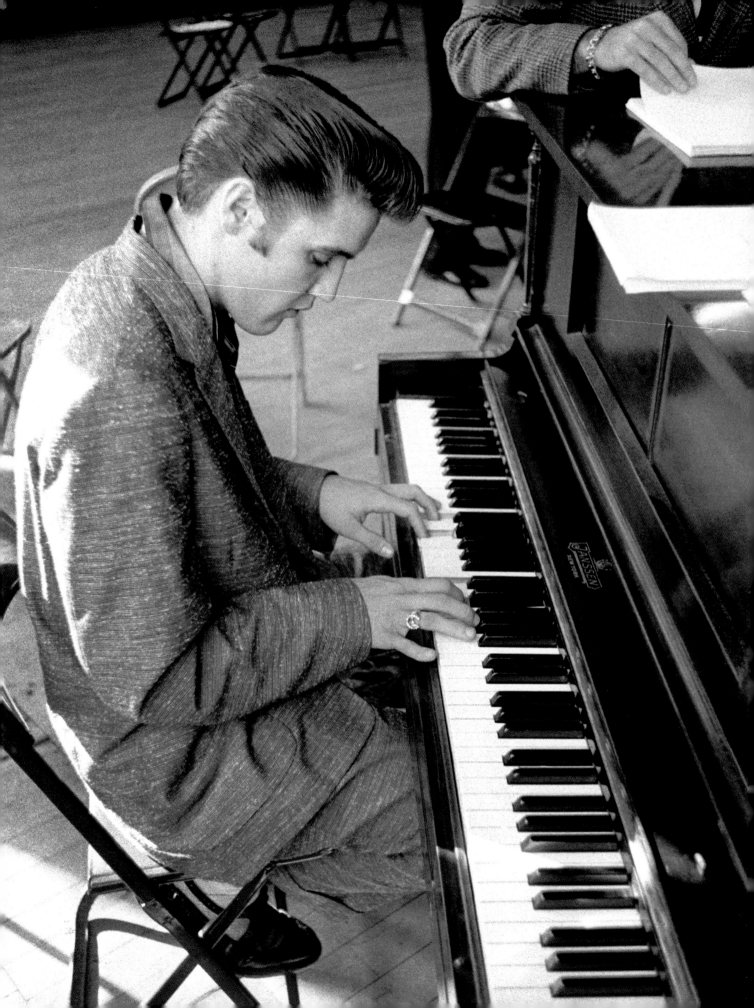

PHOTOGRAPHS BY

ALFRED WERTHEIMER

ELVIS
1956

INTRODUCTION BY

CHRIS MURRAY

ESSAYS BY

E. WARREN PERRY, JR. AND AMY HENDERSON

Published on the occasion of the Smithsonian traveling exhibition *ELVIS AT 21*

WELCOME BOOKS, NEW YORK

Thanks to Elvis Presley, whose foresight in permitting closeness,
with my camera, allowed me to achieve these personal and intimate photographs,
which otherwise would not have been possible.

Alfred Wertheimer

Contents

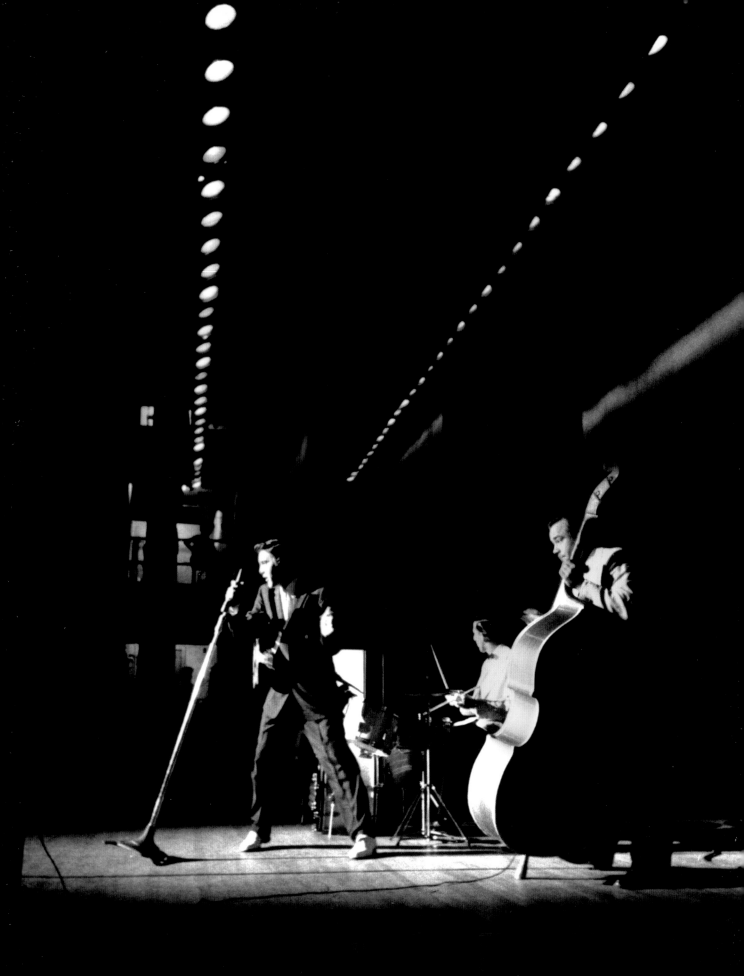

THE CROSSROADS OF CULTURE
Chris Murray

Henri Cartier-Bresson was known for photographing the decisive moment, that moment when everything falls into place. But I was more interested in the moments just before or just after the decisive moment....

—Alfred Wertheimer

WHEN PHOTOGRAPHY WAS INVENTED, it created a sensation that reverberated throughout the world. Visual imagery up to that time was the exclusive domain of artists and craftsmen. Suddenly everything changed. Now a person with a camera and some light could make a "true to life" picture of someone or something. Some people, including prominent artists, heralded photography as now, perhaps, the best way to make a picture. Others were uncertain and even fearful of this new method of image making. Some even felt the camera was the work of the devil, stealing a person's very soul.

When Elvis Presley came on the scene in 1956, he had a similar effect. Elvis's performances on TV and his recordings made him wildly popular, as he redefined American music. At the same time, his artistry caused feelings of fear and loathing among some people. His records were burned and he was denounced from the pulpit. He was accused of being immoral.

When a young freelance photographer in New York City named Alfred Wertheimer started taking photographs of Elvis Presley, he had never even heard of him. That's how fresh Elvis was when Wertheimer first observed him with his camera on March 17, 1956,

Elvis is prepared for his performance on the Dorsey Brothers'
Stage Show, New York City, March 17, 1956
OPPOSITE: Elvis and his band perform at the Mosque Theater,
Richmond, Virginia, June 30, 1956

in New York City. Elvis was appearing on *Stage Show*, the popular TV show hosted by the Dorsey Brothers. Wertheimer was hired by RCA's pop record division to take some press photos of the young, new recording artist they had recently signed. Wertheimer shot about twenty rolls of film that day with Elvis at CBS's Studio 50, where *Stage Show* was broadcast. He sent one set of contact sheets and six blow-ups for immediate use in press kits to RCA publicist Ann Fulchino, who had hired Wertheimer for the job.

Just a few months later, Elvis returned to New York City to appear on *The Steve Allen Show* and to record a few songs for RCA. Elvis and television were made for each

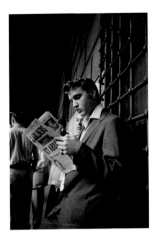

Waiting outside of Penn Station, Elvis reads about an air disaster over the Grand Canyon, New York City, July 1, 1956

other. The new medium of TV was entertaining and exciting and so was Elvis. Wertheimer photographed Elvis during rehearsals for *The Steve Allen Show*. One of those photographs, *First Arrival*, shows Elvis sitting alone at a piano singing and playing gospel music. It is a remarkable photograph that captures the charismatic twenty-one year-old in a private and unguarded moment. It was that image on the cover of *Last Train to Memphis*—Peter Guralnick's extraordinary biography of Elvis Presley—that first drew me to Alfred Wertheimer's photographs.

Wertheimer, "having a foot in the door," decided to take advantage of the opportunity to shoot Elvis again and, on his own, took a train to Richmond to photograph Elvis's two shows at the Mosque Theater. I once asked Wertheimer, what was it about Elvis that made him decide to follow and observe him as a photojournalist, and not for hire? Wertheimer replied that Elvis "permitted closeness and he made the girls cry." It was a remarkable phenomenon.

Wertheimer's photographs of Elvis in Richmond taken on June 30 are amazing. His picture of Elvis with a young woman he had just met, sitting at the Jefferson Hotel lunch counter, called *Grilled Cheese 20¢* is a classic look at 1950s America. Wertheimer's "fly on the wall" approach to photography is dramatically illustrated in a masterpiece image taken that hot summer day called *The Kiss*. Photographed in low light at the end of a long, narrow passageway under the fire stairs, *The Kiss* cap-

tures the beauty, style, and sex appeal of the young man from Memphis. Elvis's performances that evening left the audiences in a frenzy.

Wertheimer returned to New York City that night with Elvis and his band, along with Elvis's traveling companion and cousin, Junior Smith. Elvis performed live on *The Steve Allen Show* the next day.

On July 2, Elvis recorded three songs at RCA's Studio One. Two of those songs, "Don't Be Cruel" and "Hound Dog," were released as the A and B sides of the same single. To this day, it is the only single ever released where both sides went to number one on the record charts. Alfred Wertheimer was there, in Studio One, documenting that legendary recording session. Wertheimer's photographs of that session are a rare record of a great moment in American music. They capture Presley in full command of his artistry, not only as a singer and musician, but also as musical arranger of the sessions themselves.

The next day, Presley, along with his band, his manager Colonel Tom Parker, Junior Smith, and Wertheimer, boarded a train at New York City's Penn Station. Elvis was returning home to Memphis and a much-anticipated concert at Russwood Park stadium. After their hometown boy made it big on TV in New York City, this concert was going to be a homecoming of sorts. It was a 27-hour trip home, and Elvis spent some of the time listening to the acetate copy he had of his three new songs, playing them over and over on his portable record player. Wertheimer's pictures of Elvis on the train reveal a young artist deeply and critically immersed in his music. Presley's absorption in his music was not a casual thing.

When the train finally got near Memphis, Elvis asked to get off at a stop near the outskirts of town called White Station. It was closer to his home on Audubon Drive than the main station in Memphis. Wertheimer did not miss this moment with his camera and as a result, he captured a truly remarkable series of images of Elvis walking as a regular person for what may have been the last time. Wertheimer describes that moment:

With only the quick acetate cuts, no luggage or instruments, he hopped off the train and headed down a grassy knoll towards the sidewalk of this little town. Between telephone poles and Cadillacs, Elvis stopped to ask a black woman on the street for directions and then turned to wave to us on the train. As the train started moving, I quickly figured that I was better off taking pictures of what was going on in front of me instead of jumping off the train and following Elvis. If I had stopped to collect my bags and all my equipment, I would have missed what was probably one of the last times he could just walk down the street like an ordinary guy.

Within a few short months, Elvis Presley would be the most talked-about entertainer in the world. No one would ever again be able to photograph Elvis as Alfred Wertheimer had. Wertheimer captured Elvis at a crossroads of culture. He, with his camera, was our witness to the hero's return.

When Elvis reached Audubon Drive, he was welcomed home by his beloved mother, Gladys, his father, Vernon, his grandmother, Minnie Mae, and his high-school sweetheart, Barbara Hearn, along with other cousins, friends and neighbors. Wertheimer photographed Elvis's homecoming, even going so far as to photograph Elvis while swimming with him in his new pool and while riding with him on the back of his Harley Davidson motorcycle. Wertheimer has repeatedly said that "Elvis permitted closeness," and he appreciated the opportunity to get close to Elvis as a photojournalist.

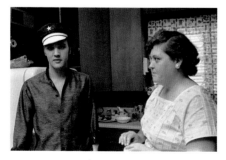

Elvis with his mother Gladys, 1034 Audubon Drive, Memphis, Tennessee, July 4, 1956

Wertheimer accompanied Elvis to his concert that evening at Russwood Park stadium. The sheriff arrived at the Presley home in his police car. Elvis sat in the middle of the front seat, in between the sheriff and the colonel. Wertheimer sat in the backseat alone. When they arrived, Wertheimer photographed Elvis moving through the surging crowd that was trying to get as close as possible to him.

Elvis was dressed all in black when he took the stage, backed by Scotty Moore on the guitar, Bill Black on bass, and D. J. Fontana on drums. Elvis and his band were as tight as could be. The air was electric. Fourteen thousand people were on hand to celebrate the new, liberating, and thrilling music performed by one of their own. Just a few days earlier, Elvis had had to follow a script and perform in a tuxedo on *The Steve Allen Show* in New York City. Feeling good and happy to be home, Elvis told his Memphis audience, "Tonight, you're going to see what the real Elvis is all about." Elvis put on a mesmerizing performance, the crowd loved it, and Wertheimer photographed it all.

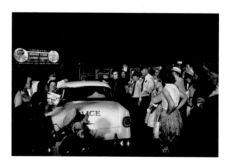

Elvis waves to his fans upon arriving for his performance at Russwood Park that night, Memphis, Tennessee, July 4, 1956

After Elvis left the stadium, Wertheimer hopped a night train back to New York City. Elvis went on to unprecedented fame and fortune as a musical artist. But it is Alfred Wertheimer's photographs, and his alone, that remind us of a time in America when a young man from Mississippi could change the world with a song.

We are fortunate indeed to have Alfred Wertheimer's photographs of Elvis Presley in 1956. They are the most compelling photographs of the greatest rock 'n' roll icon of all time.

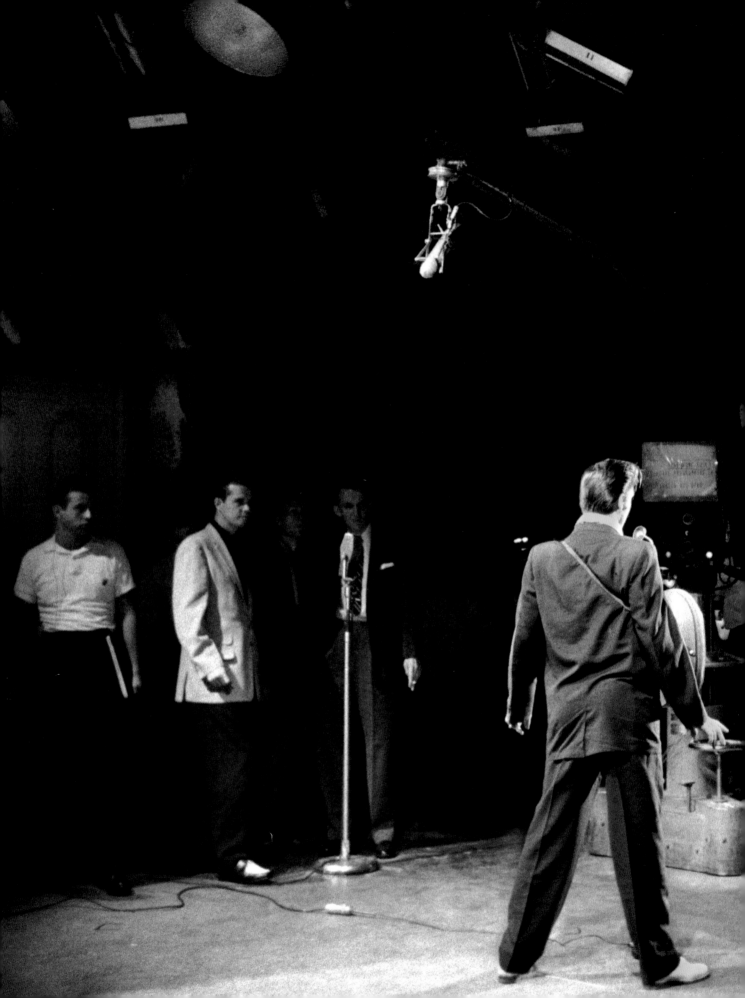

ELVIS: RETURN OF THE HERO

E. Warren Perry, Jr.

A hero ventures forth from the world of the common day into a region of supernatural wonder: fabulous forces are there encountered and a decisive victory is won: the hero comes back from this mysterious adventure with the power to bestow boons on his fellow man.

—Joseph Campbell, *The Hero with a Thousand Faces*

ELVIS PRESLEY'S JULY 1956 RETURN TO MEM-phis was the end of an adventure. On one level, the occasion was a simple homecoming; on another level entirely, this event symbolizes a mythic pattern as old as all of literature. Curator Chris Murray tells us that Al Wertheimer, "with his camera, is our witness to the hero's return." And although the no-

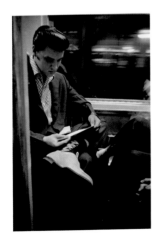

Elvis reads fan mail while on the train to New York from Richmond, Virginia, July 1, 1956
PRECEDING SPREAD: Elvis and the Jordanaires rehearse for *The Steve Allen Show* at the Hudson Theater, New York City, July 1, 1956

tion of the youthful Elvis as a returning hero may seem something like meta-lionization, this young entertainer returned to Memphis, Tennessee, having experienced worlds never imagined by his mother and father, and therefore was a powerful conquering figure.

Elvis's beginnings were about as common as they could be; both sides of his family were poor and his father, Vernon, had even spent time in Parchman—a Mississippi delta hellhole of a prison—for forgery. There was certainly nothing in his bloodline that could foreshadow Elvis's rise to fame. That fact, however, plays into the machinations of the rags-to-riches motif. Elvis's story is the Horatio Alger tale of the atomic age in which hard work, good fortune, and a nice smile yield results that rise exponentially beyond the middle-class definition of success.

By 1956, Elvis had traveled throughout the South and performed at the Grand Ole Opry in Nashville—the pantheon of country music—and at the more car-nivalesque environment of the Louisiana Hayride in Shreveport. In Homeric terms, 1955 was Elvis's Iliad. Just as the Greeks cut a swath through Troy, so Elvis

Teenage fans outside the rear of the Mosque Theater listen to Elvis and the Jordanaires rehearse, Richmond, Virginia, June 30, 1956

and his band, the Blue Moon Boys, featuring Scotty Moore, Bill Black, and D. J. Fontana, stormed through the south and Texas, getting attention everywhere they toured and putting screams in the throats of Elvis's increasing legion of young female fans. And if 1955 was the Iliad, then 1956 was surely the Odyssey. Elvis's 1956 excursion from Memphis to New York and back, with the additional journey south to Richmond, is reasonably comparable to Odysseus's wanderings among the lotus eaters and the sirens, as Elvis, like Odysseus, was certainly seeing and experiencing beyond the realm of his Ithaca.

The early life of Elvis Presley the entertainer is a testimony to the fact that historical processes sometimes feed into mythical patterns. Of course, Elvis was not Odysseus. He was also not King Arthur, Percival, or Superman. As Joseph Campbell observes, though, the life of a given hero has certain characteristics in common with the lives of *other* heroes. Was Elvis a hero? Perhaps not, but there are moments of his life wherein his world must have seemed to him to be fantastic and un-worldly.

Beginning with his road trips in 1955, and in full motion by 1956, Elvis was living his life inside the pattern of a myth. Like Joseph Campbell's hero, Elvis ventured "forth from the world of the common day." He left his hometown, his job as a truck driver for Crown Electric, and his mundane surroundings, and entered "into a region of *supernatural wonder*..." Although Elvis never precisely witnessed supernatural wonder in his perambulations, he certainly saw a lot of things he never saw

growing up in Memphis, Tennessee—show business at its provincial roots on tour and at its refined apex in the television and recording studios of New York City. Being a good son and a churchgoer, Elvis must have wondered what kind of magic he was spinning the first time young girls screamed and cried at his performances. By the time he appeared on *The Steve Allen Show*, he was aware of his legerdemain and its effect on a population of ingenues. And he achieved a "decisive victory" over "fabulous forces" when he overcame the condescension and belittling efforts of an obviously disrespectful Steve Allen to win the love and attention of the American audience.

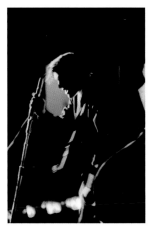

Elvis in motion onstage at the Mosque Theater, Richmond, Virginia, June 30, 1956

In the end, again, per Campbell, "The hero comes back from this mysterious adventure with the power to bestow boons on his fellow man." Elvis returned to Memphis after great national television exposure and after advancing high up the ladder of fame in a very short time. What boons did he bestow on his fellow man? To his fans he gave the gift of himself...to his friends and community he was charitable to his final days, and to his family he gave everything imaginable from his newly gained fortune. Among the gifts he bestowed on his mother were the legendary pink Cadillac and, in early 1957, Graceland, a grand Southern mansion which, like Camelot, would become as famous as the king who inhabited it.

THE FLASHPOINT OF FAME

Amy Henderson

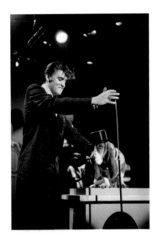

Elvis rehearses singing "Hound Dog" to a bassett hound for
The Steve Allen Show, New York City, July 1, 1956

I N 1956, ELVIS HIP-SWUNG POSTWAR AMERICAN culture out of complacency. Gradually at first, and then inexorably, he altered the beat of everyday life. The world changed.

It was an era that embraced the idea of "peace and prosperity," conspicuous consumption, cars with fins, and men in gray flannel suits. Most of all, it was an age of conformity, and Elvis's electrifying intrusion was as shocking as Sputnik would be a year later: he energized the emerging youth culture and helped create a new consumer market fueled by radio, recordings, and movies. His enormous popularity also helped catalyze a revolution in the entertainment industry, paving the way for rhythm and blues, gospel, and rock into mainstream culture.

Remarkably, his journey to fame happened within a year—January 1956 to January 1957—and testified to the emerging importance of television as a cultural denominator. Elvis made his first live television appearance at 8 P.M. on January 28, 1956, on the Dorsey Brothers' *Stage Show*, broadcast from New York; this CBS program was produced by Jackie Gleason and existed mainly as a warm-up for Gleason's own hit show, *The Honeymooners*, which followed immediately. Virtually an unknown personality at this point, Elvis sang "Shake Rattle & Roll" and "I Got A Woman," and suddenly, magic happened: it was reported that "hundreds of girls began screaming" when he came onstage and sang. Two days later, Elvis made his first recordings for his new studio, RCA—a session which produced the hit "Heartbreak Hotel."

He appeared on five more Dorsey shows in late winter and early spring. In the midst of these broadcasts in March, RCA noticed the incipient Elvis groundswell and hired Alfred Wertheimer to take publicity photographs of their new protégé. Luckily for history, Wertheimer chronicled the Elvis phenomenon over the next several months, and was there to capture his extraordinary transit to superstardom.

The "cool medium" of television became a key player in Elvis's heat-seeking stardom. His appearances on the Dorsey shows were followed in April and then in early June by live performances on *The Milton Berle Show*, where he propelled audience pandemonium by singing "Hound Dog" and "I Want You, I Need You, I Love You." The frenzied reaction of the television-studio audience not only fed his fame, but broadcast a "way to behave" that motivated crowd exhilaration as his fame

mounted. By the time he ultimately made three appearances on *The Ed Sullivan Show* (in September, October, and January) his audience numbered 60 million out of a total population of 169 million Americans. The press perked up, and contributed a new sobriquet to the cultural lexicon, "Elvis the Pelvis." America's keepers of tradition were also waking up: television critic John Crosby of *The New York Herald Tribune* described Elvis's performance on the Berle show as "unspeakably untalented and vulgar." By this point, Elvis was beginning to be lumped with such other new cultural icons as James Dean, and red flags of warning sprouted across the landscape: PTAs in particular cautioned parents about dangerous role models who fomented juvenile delinquency.

Television's small screen continued to carry the sights and sounds of cultural transformation. Still in its youth, TV was live and in black-and-white—a perfect metaphor for Cold War America, where (as we learned from watching Westerns) the Good Guys were distinguished from the Bad because they wore white hats instead of black. On July 1st, Elvis appeared on *The Steve Allen Show*. Steve Allen was the popular host of this prime-time TV variety show, and saw himself as a cultural steward: shocked—shocked!—by rock 'n' roll, he enjoyed mocking the lyrics of hit songs on his show.

By July 1956, Elvis was fair game. Although Allen was worried about suggestive hip gyrations—this was live TV after all!—he felt he could keep control of his program if he had Elvis introduce his new single ("Hound Dog") while wearing top hat and tails and singing to a basset hound. Elvis took it all in stride and performed with great elan. Even the basset liked him.

Before leaving New York, Elvis recorded "Hound Dog" and "Don't Be Cruel" at the RCA studio; he then embarked on a twenty-seven hour train journey home to Memphis. He was still remarkably alone. Traveling with a small entourage, he was unrecognized and able to mix unnoticed with everyone else on board, family and strangers, black and white. The train ride was redolent of a different America altogether, a passage unimaginable in today's high-octane celebrity world. It was a journey rolling through cities, small towns, and farmland with "all deliberate speed," and it suspended Elvis in time and place. Traveling home, he listened to the records he had just cut, read magazines, and looked out the window, waiting. When the train stopped to let him off near his home, he walked away and waved back. Whether he realized it or not, it was a farewell gesture to the world that had brought him this far.

The Memphis visit began as a respite, with Elvis visiting his parents and, like one of his own heroes, Marlon Brando, riding around on his motorcycle outfitted like Brando in *The Wild One* (1954). But then he went to work, and this chapter of his life was over.

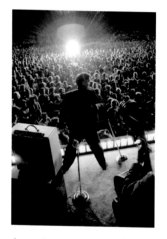

Starburst, Elvis onstage at Russwood Park,
Memphis, Tennessee, July 4, 1956

With a cinematic luminosity, photographer Alfred Wertheimer had chronicled a time from when Elvis could sit alone at a drugstore lunch counter to the beginning of the rest of his life, when he could no longer stroll unnoticed down any street in the world. The concert at Russwood Park in Memphis marked this transformation: Elvis now had to be escorted from his limousine into the stadium by a police phalanx that separated him from his fans. Once he was onstage, the air exploded, and at one point, as light sprayed around Elvis, Alfred Wertheimer captured a veritable "starburst"—the flashpoint of fame.

THE PHOTOGRAPHS

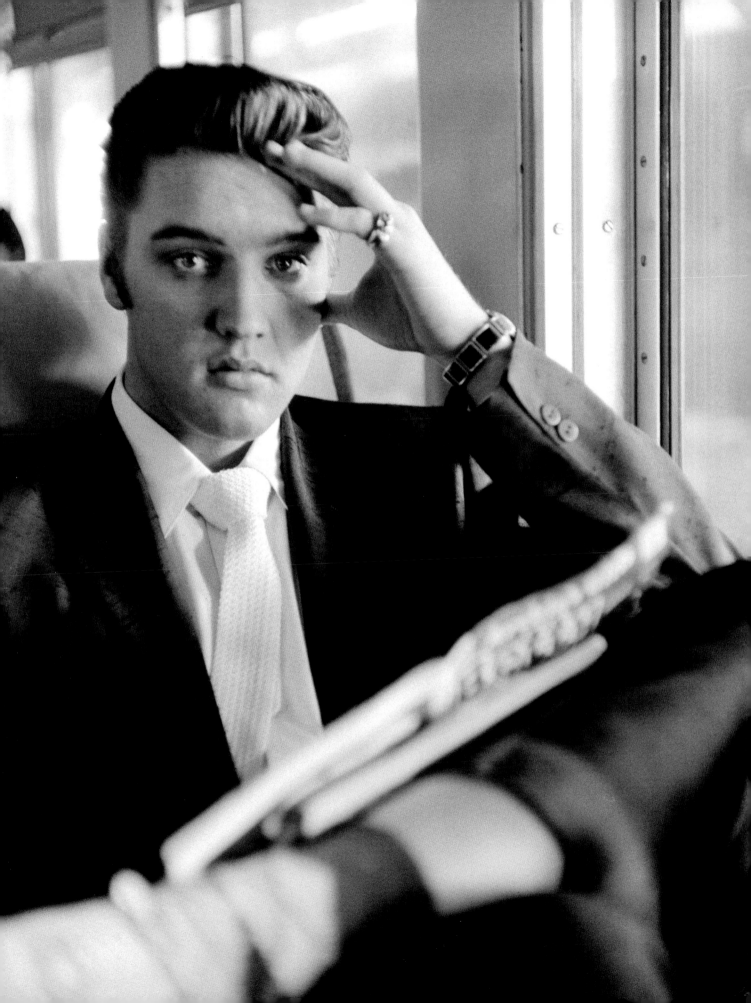

March 17, 1956. New York City.

Barely known on the national scene, a twenty-
one-year-old Elvis Presley could walk alone and
unrecognized on a night street in New York City.

Recently signed by RCA Victor from Sun Records,
Elvis traveled to New York to record under his new
label and to appear on the Dorsey Brothers' *Stage Show*.

RCA hired Alfred Wertheimer, a twenty-six-year-
old freelance photojournalist, to shoot promotional
images of their rising star.

Wertheimer's intuition to "tag along" afterward, and
Elvis's instinct to permit closeness—the same instinct
he exhibited onstage—produced an astounding series
of photographs.

Elvis is the subject. America is the setting. Both were
on the verge of transformation.

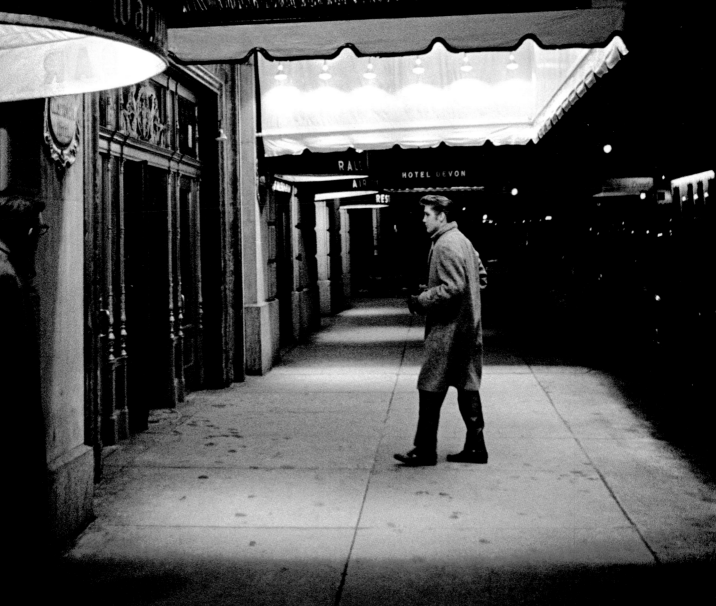

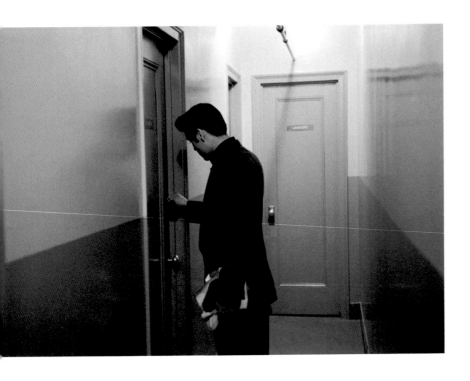

Once Elvis finished reading, he tore each letter up into little shreds and put them on the coffee table. "Why are you doing that, Elvis?" "I'm not going to carry them with me. I've read them and seen what's in them. It's nobody else's business."
— Alfred Wertheimer

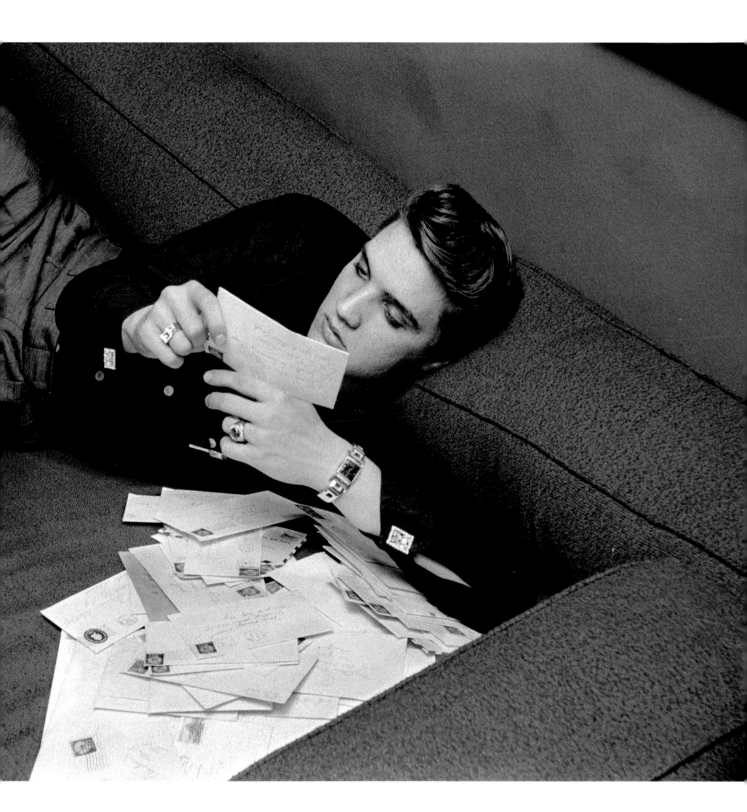

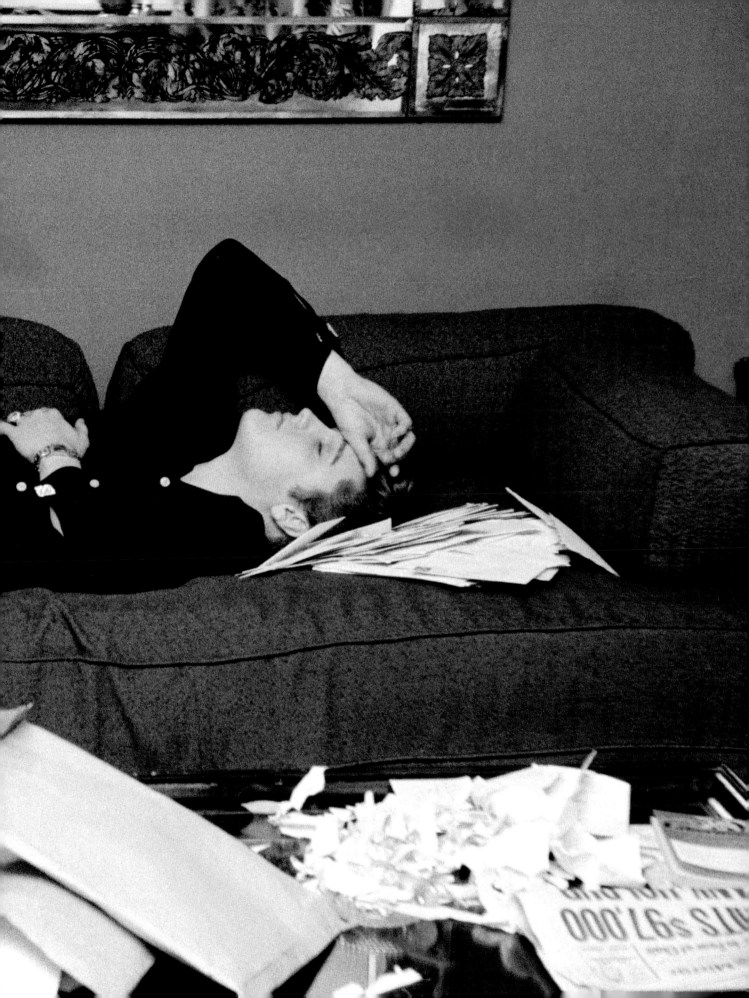

Elvis moved like no other white entertainer—gyrating his hips, shaking his shoulders, leaping in the air. His moves, his alternating smile and sneer were all calculated with genius and excited a visceral reaction in his audiences.

He swung a hip, girls screamed. He grinned back and swung another hip—the air sizzled.

His posture, his long hair coming uncombed as he danced, and his dark eyes and sideburns conveyed a smoldering sensuality that left audiences in a frenzy.

He created his own style, buying his clothes at Lansky Brothers in Memphis, a store that sold primarily to African Americans. Soon, his look would be the look.

Walls were falling.

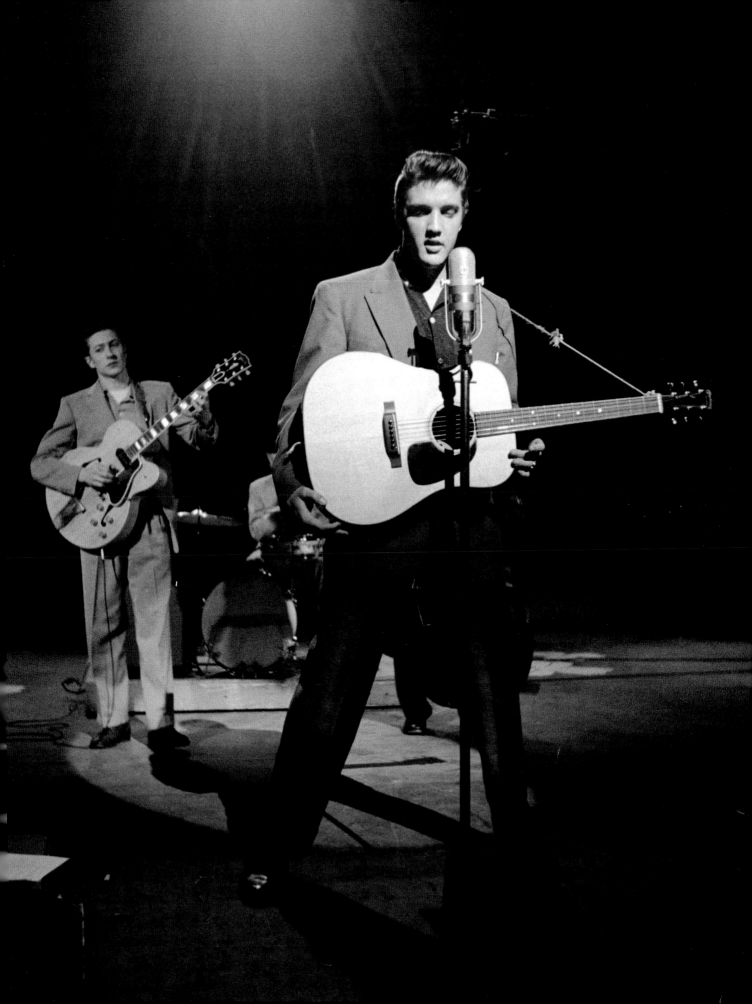

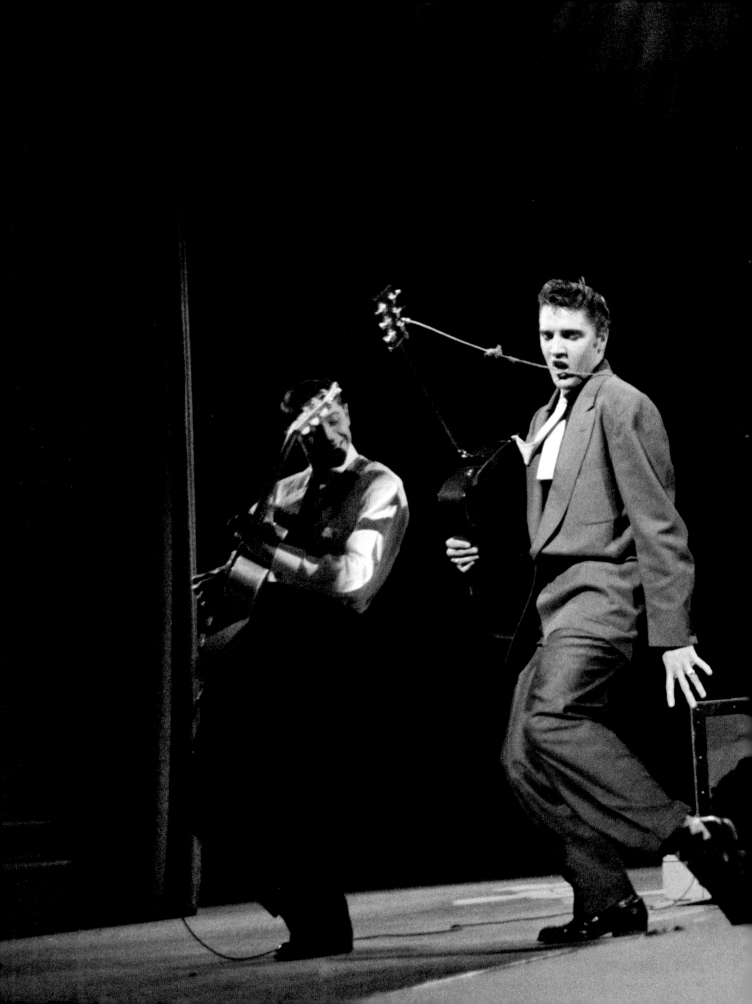

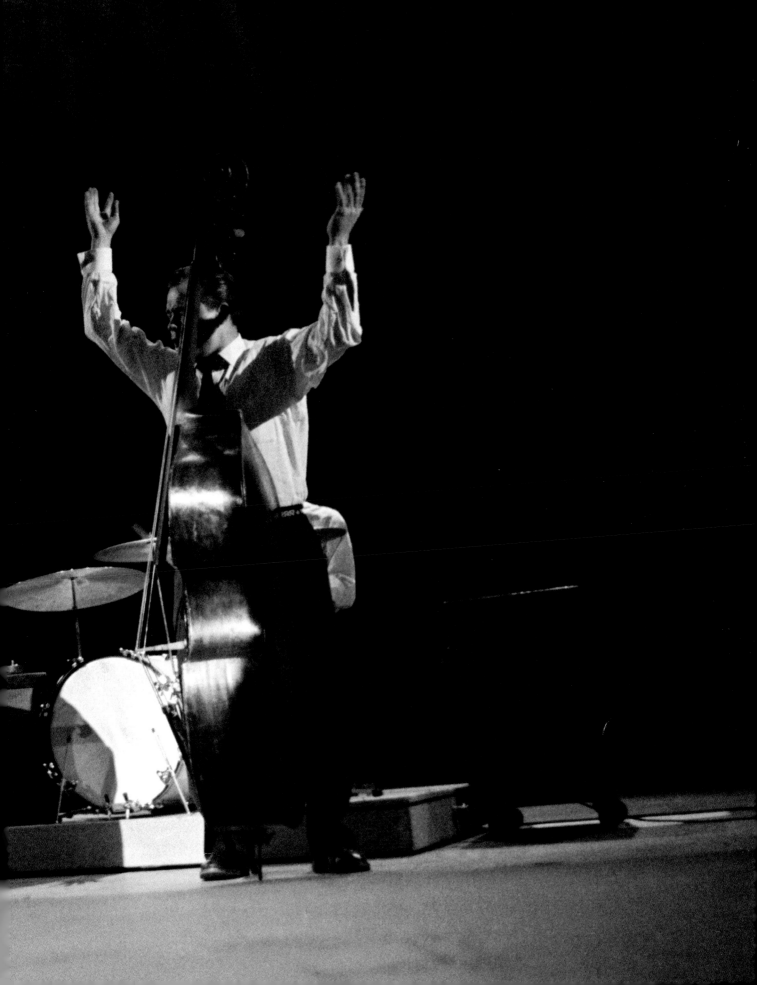

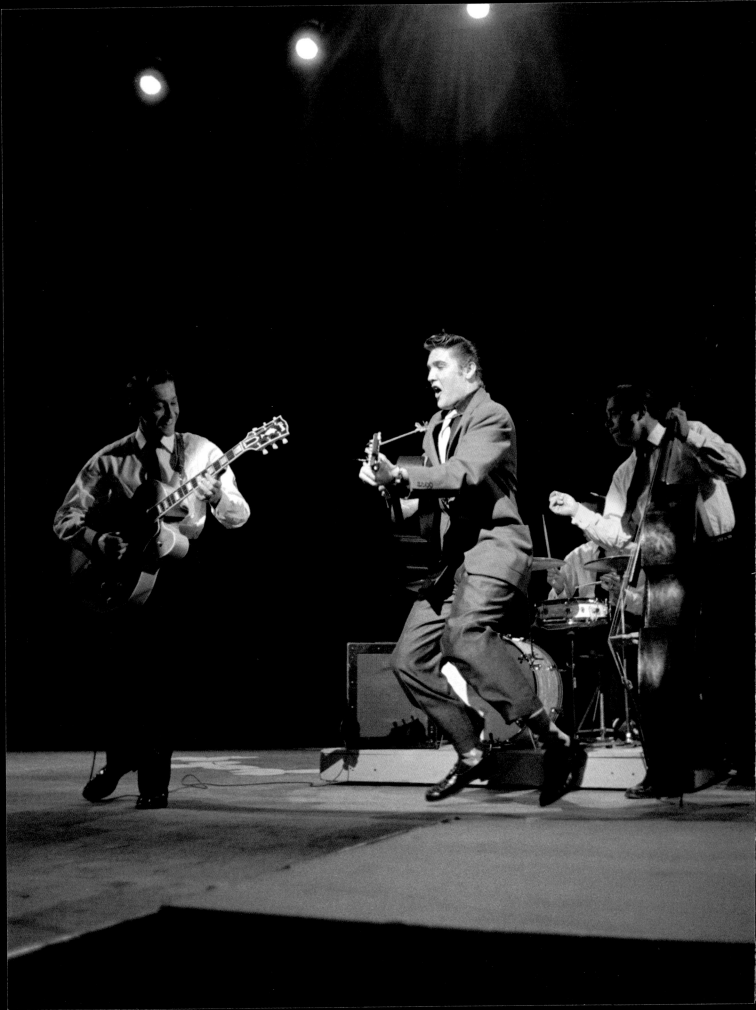

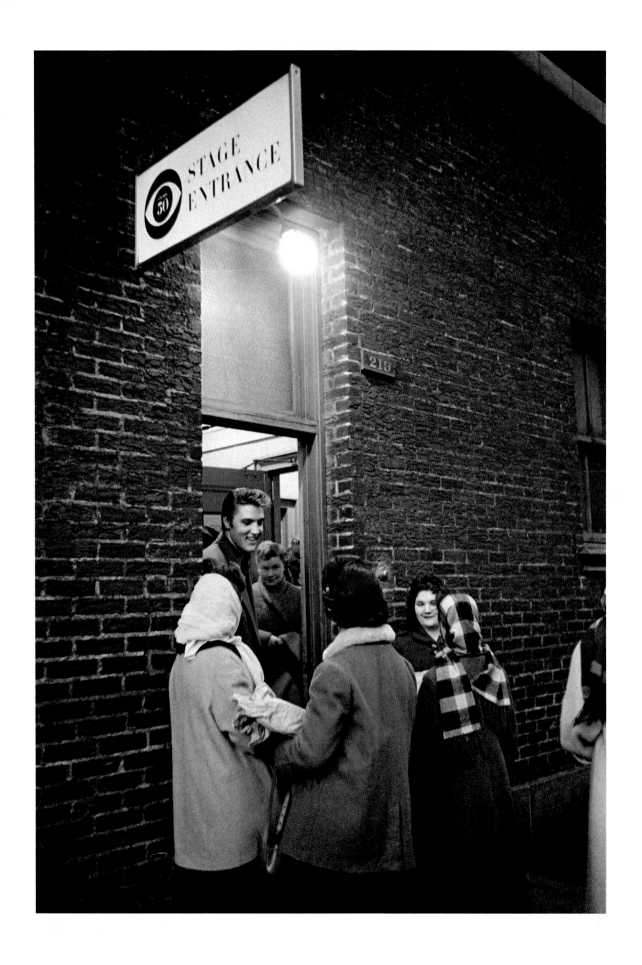

June 30, 1956. Richmond, Virginia.

A few months after his TV performance, Elvis went to Richmond for two shows at the Mosque Theatre. Getting off the train, he turned on his RCA portable radio.

Wertheimer watched Elvis exit the train station with his radio blaring: "I took a picture of him from the rear, which, in retrospect, really captures Elvis's pelvis." Elvis and his cousin Junior Smith then got into a cab and headed for the Jefferson Hotel.

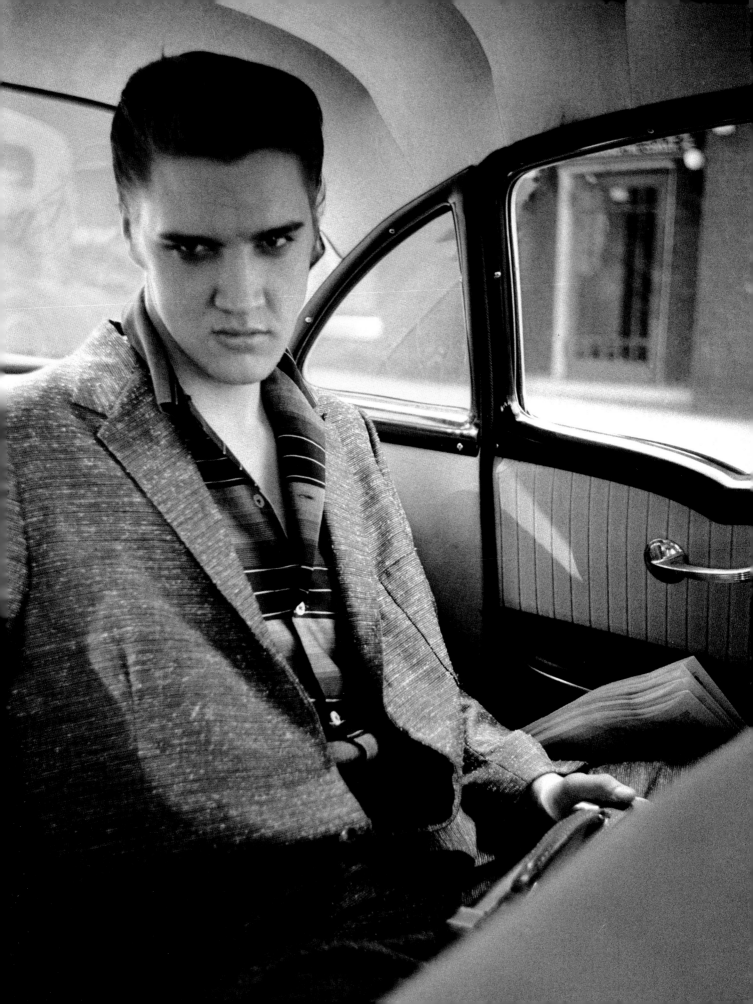

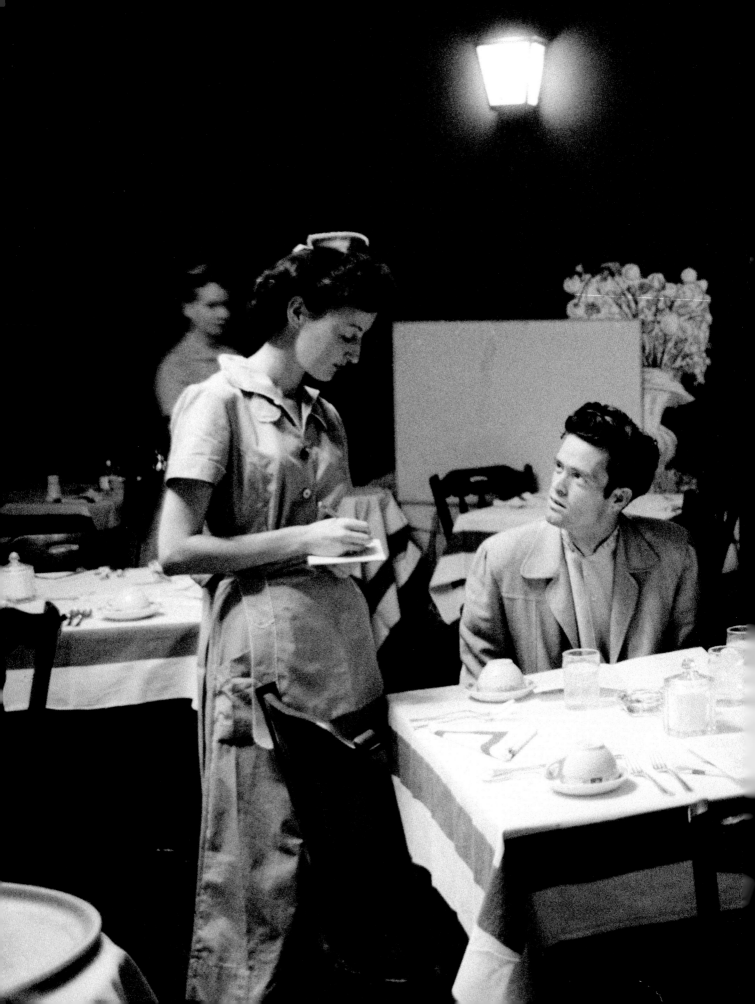

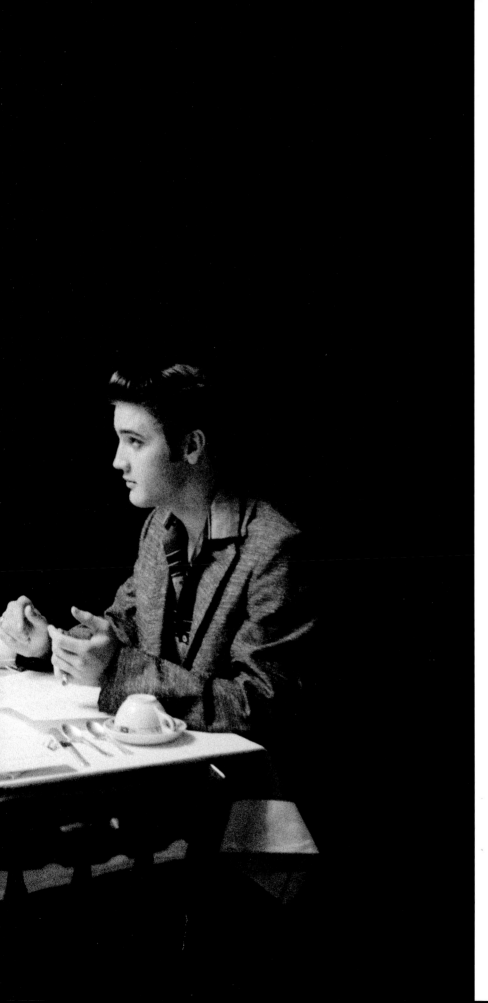

Elvis and his cousin Junior sat down and the waitress brought the menus over... within fifteen minutes of their first encounter, Elvis had his arm around the waitress's waist. While his cousin Junior Smith was scrunching his forehead in that typically ominous way, Elvis just naturally knew how to get to the ladies. How often have you put your arm around a woman you never knew existed just twenty minutes earlier? He was charming and she loved it.
— Alfred Wertheimer

June 30, 1956. Night of the performance, Richmond, Virginia.

Wertheimer enjoyed virtually unlimited access to Elvis.

I guess he felt that somebody should be photographing him because one of these days he was going to be famous. People asked me later on, "What was so different about Elvis?" I didn't know at the time, but I would soon understand that first of all, he permitted closeness and second, he made the girls cry.
— Alfred Wertheimer

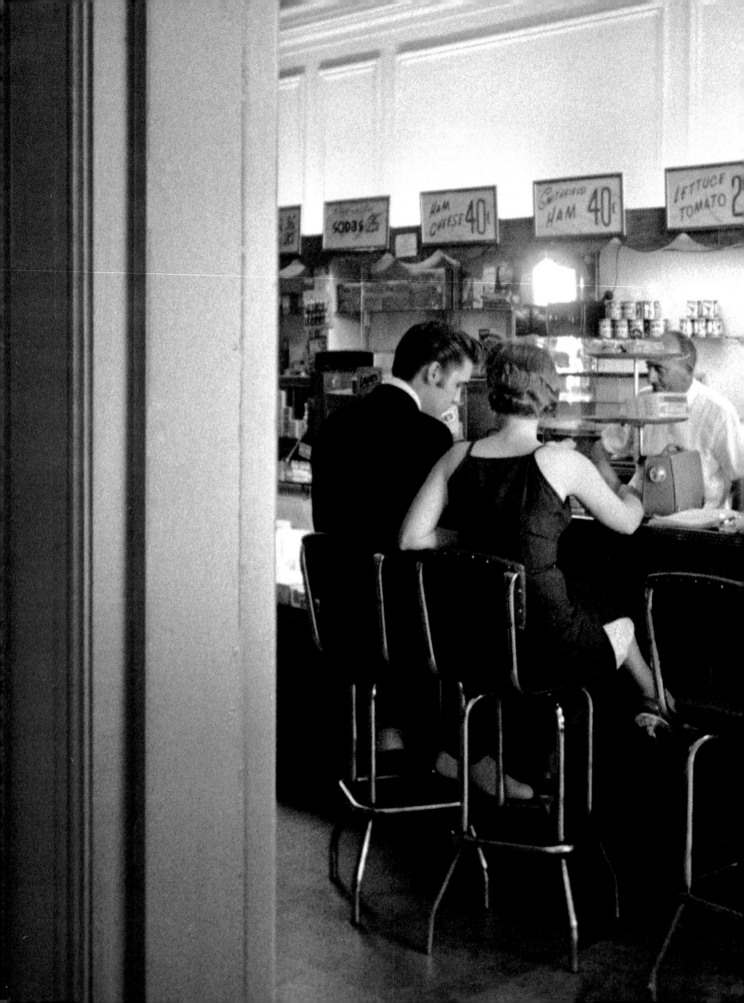

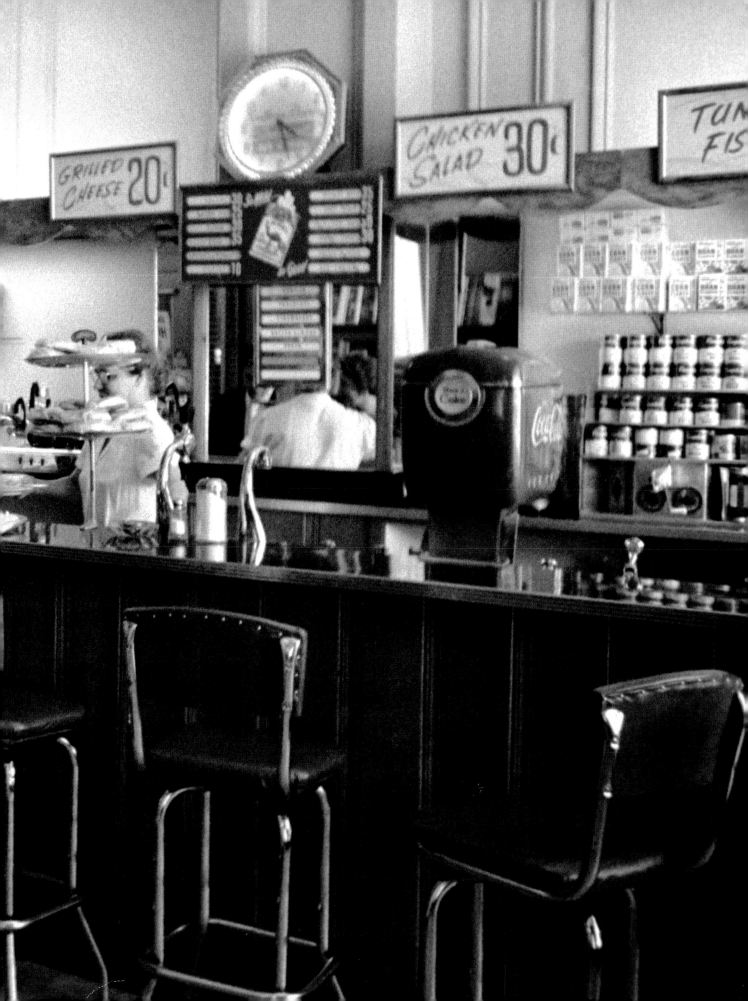

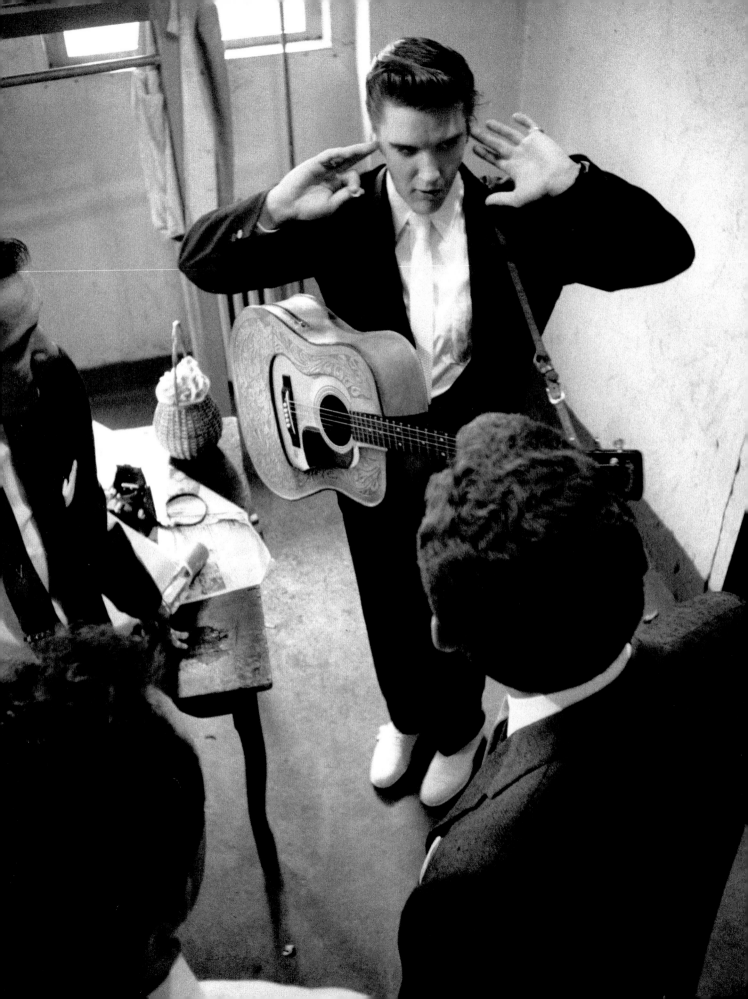

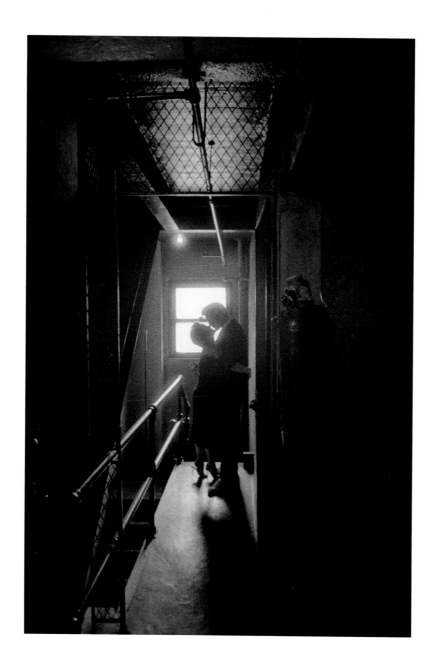

*Elvis and his musicians were getting dressed in the men's room.
Suddenly, I noticed that Elvis was gone. He had disappeared when I
turned to take a few more pictures. A photojournalist was supposed
to stay near his subject.*

*I found Elvis with his girl for the day, the one from the hotel
luncheonette. There was a very intimate feeling about the situation.
They clearly wanted privacy but I took my chances and moved in
closer. Elvis remained oblivious to me.*

— Alfred Wertheimer

…In order to capture it on film, I had to bring the exposures down to one half—maybe one fifth—of a second and click a few shots with both my wide-angle and my medium telephoto lens from about twenty feet away. I had to get in a bit closer.

…I was worried about how Elvis was going to react to the invasion of his privacy. He couldn't have cared less; his focus was entirely on giving this girl a kiss.

— Alfred Wertheimer

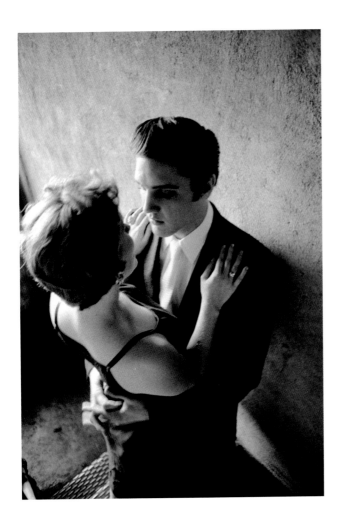

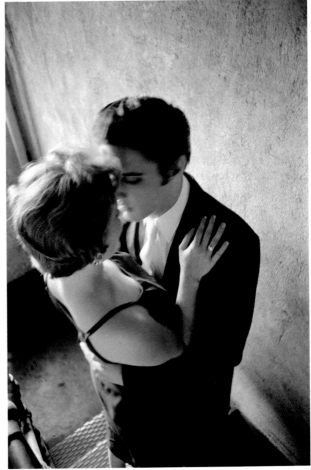

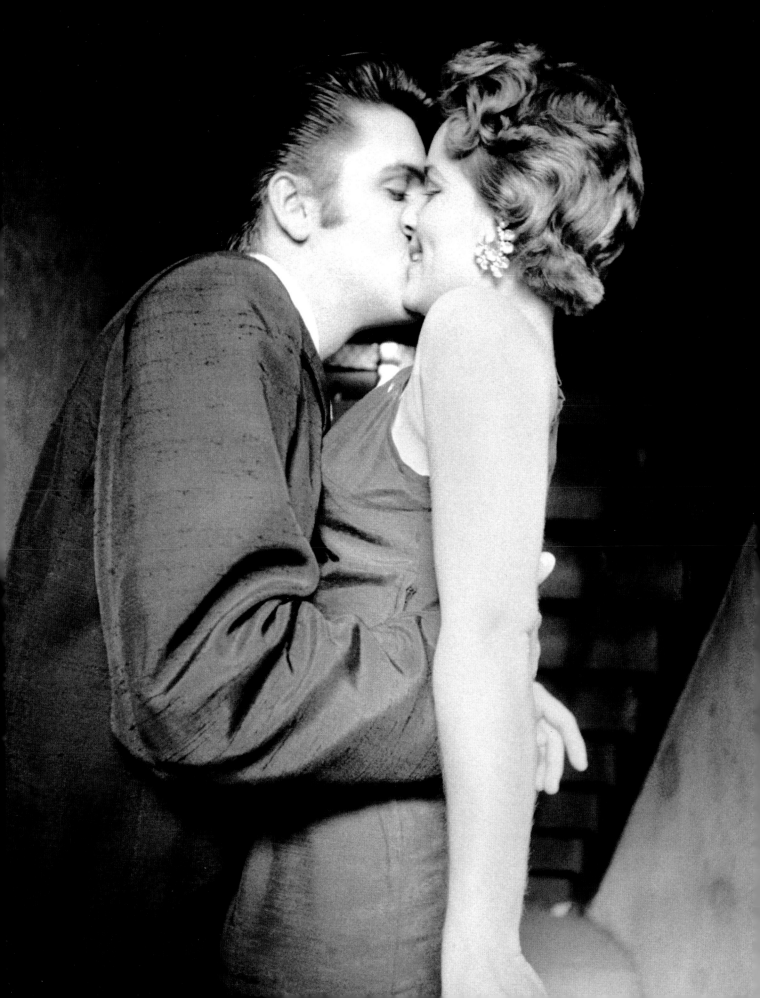

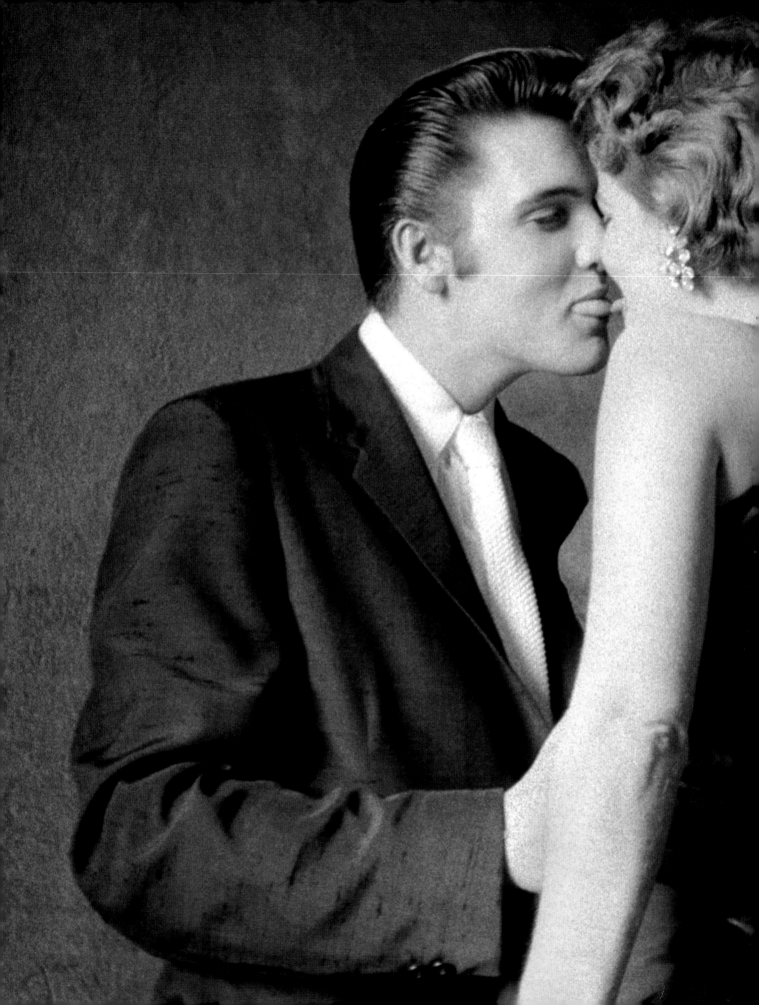

Elvis came out from the back, combed his hair one more time, grabbed his guitar, and jumped onstage in front of 3,000 screaming fans.

Elvis was working up a sweat, being very intimate and letting the girls see him fall apart on stage. That got them excited. They started to cry, clutching each other while mascara ran down their cheeks. They were having such a good time falling apart with him and he loved it.

There was such a feverish pitch that the police kept watch with their squinty eyes to make sure nothing was going wrong.

— Alfred Wertheimer

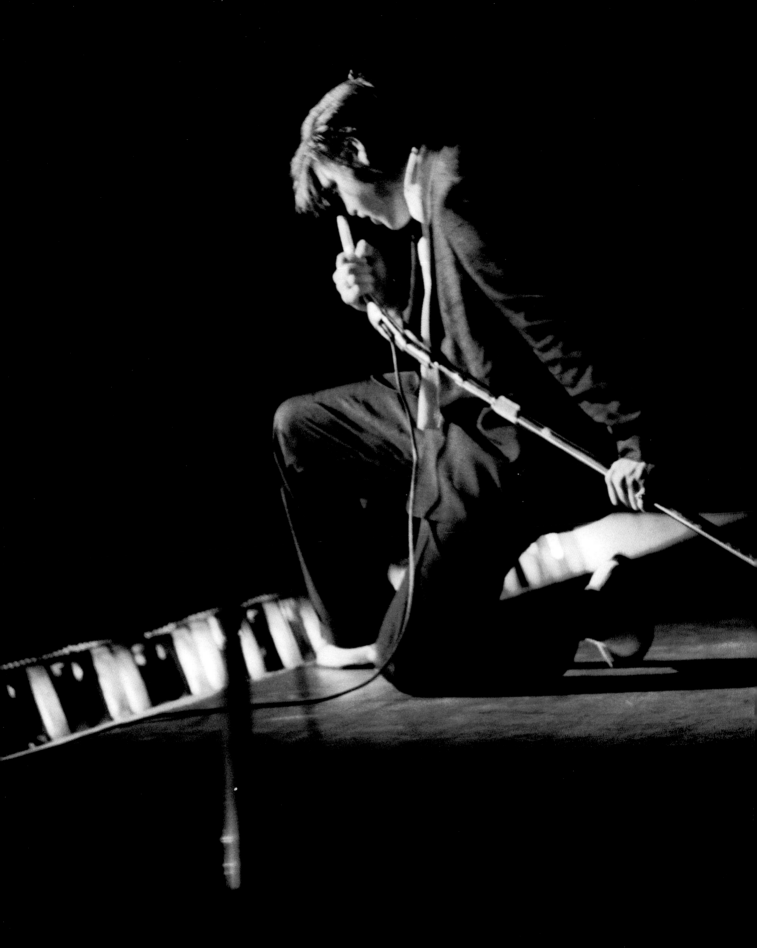

July 1, 1956. New York City.

As Elvis and Junior Smith got out of the cab in midtown Manhattan,
we were greeted by a girl in a white dress and her father. Her father had
brought her into the city from Long Island.
 Holding her hand tightly, Elvis looked into her eyes and listened
to her story. Her father stood a few feet away. Junior Smith was busy
dragging out the guitar case. Somebody, not Elvis of course, took care
of paying the cabbie. He told her some beautiful things that she wanted
to hear. Then he said, "I've got to go now. I have a rehearsal," and
disappeared into the Hudson Theater.
 Everyone else went in but I kept my camera on her. I continued
shooting as she broke down and started to cry.
 — Alfred Wertheimer

The girl's white-gloved propriety reflected the traditional
culture that Elvis was shattering.

The gloves were coming off.

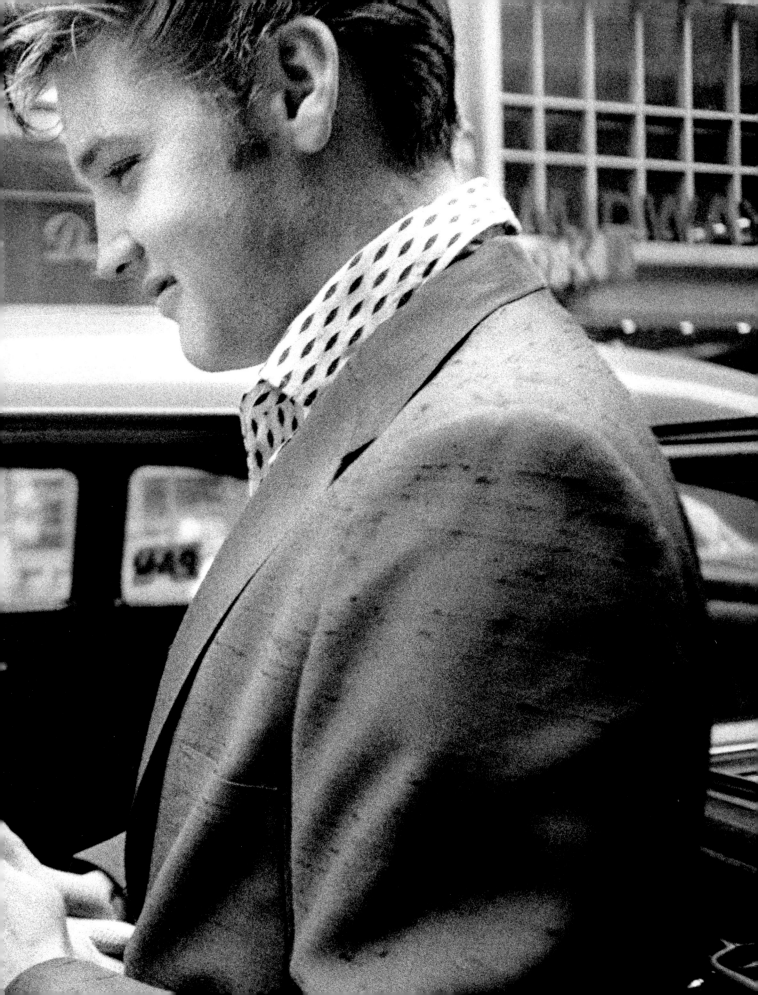

Getting there a little early, I entered this large informal space to find Elvis over in the corner. He was playing the piano by himself... Junior Smith was just hanging around while Elvis played some gospel music... He always needed an excuse to get away from the conversation. Whether it was an accordion, guitar, or piano, he would pick up whatever musical instrument happened to be there. It was his way of calming himself down and letting people know that he was absorbed in his music. The agents and others that started arriving were impressed by the fact that Elvis could even sing gospel or play the piano. Everyone always thought of him as a rock 'n' roll singer.

— Alfred Wertheimer

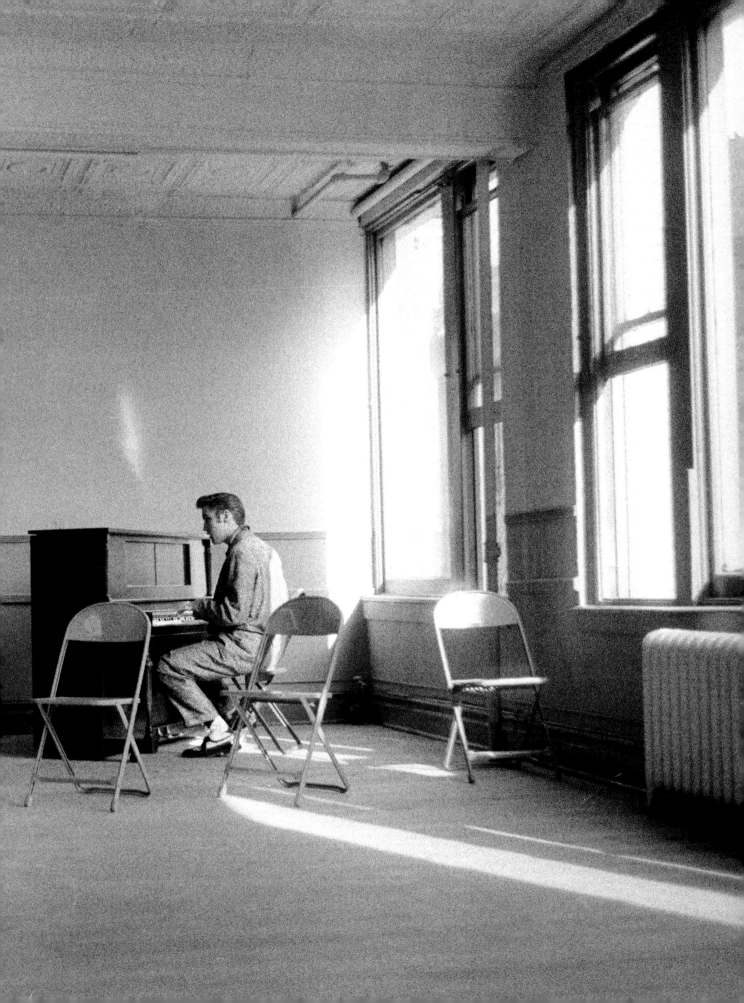

July 1, 1956. *The Steve Allen Show*, New York City.

As Elvis rehearsed for an appearance on *The Steve Allen Show*, national media buzzed with backlash against Elvis's hip-swinging performance on Milton Berle's show just a few weeks earlier. Conservative critics called Elvis a "disciple of the devil."

Still in its youth, TV was live and in black-and-white. Steve Allen was the popular host of a prime time variety show, and saw himself as a cultural steward. To capture the ratings without the controversy, Allen would have to try to contain Elvis.

He did it by writing skits to tame the raw power of Elvis's performances—having Elvis sing "Hound Dog" to a basset hound in a top hat, and casting Elvis as "Tumbleweed Presley" in a "Range Round-Up" spoof.

In that skit, featuring Imogene Coca, Andy Griffith, and Steve Allen along with Elvis, Allen signified his own importance by wearing the biggest white hat.

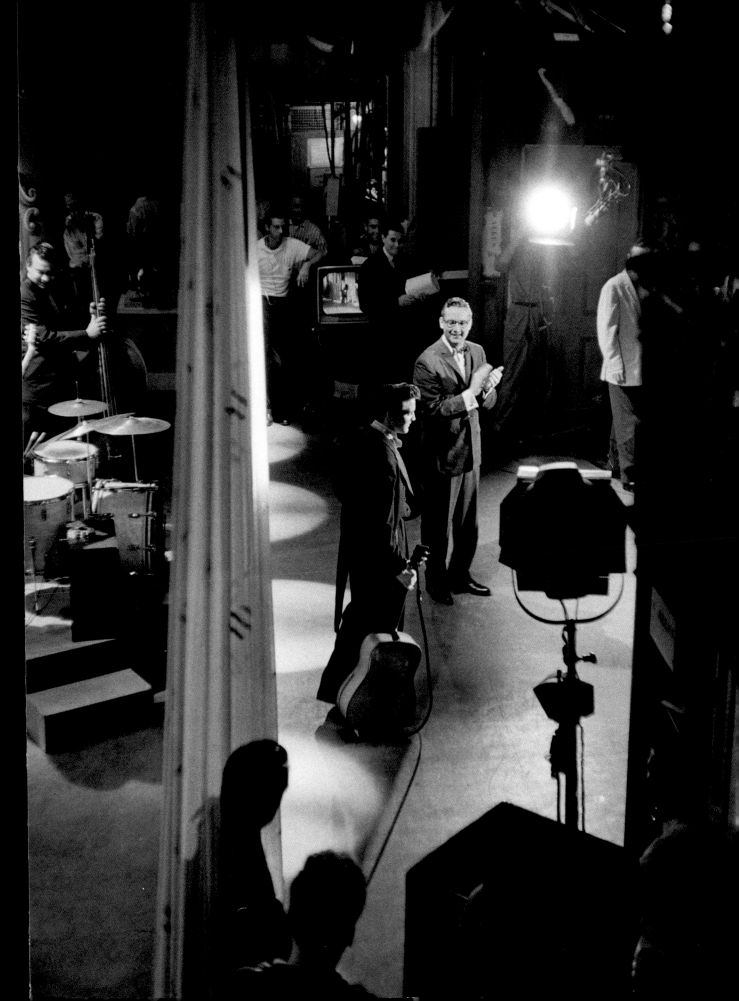

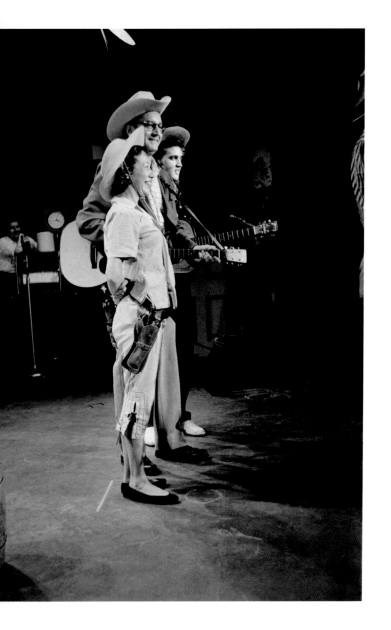

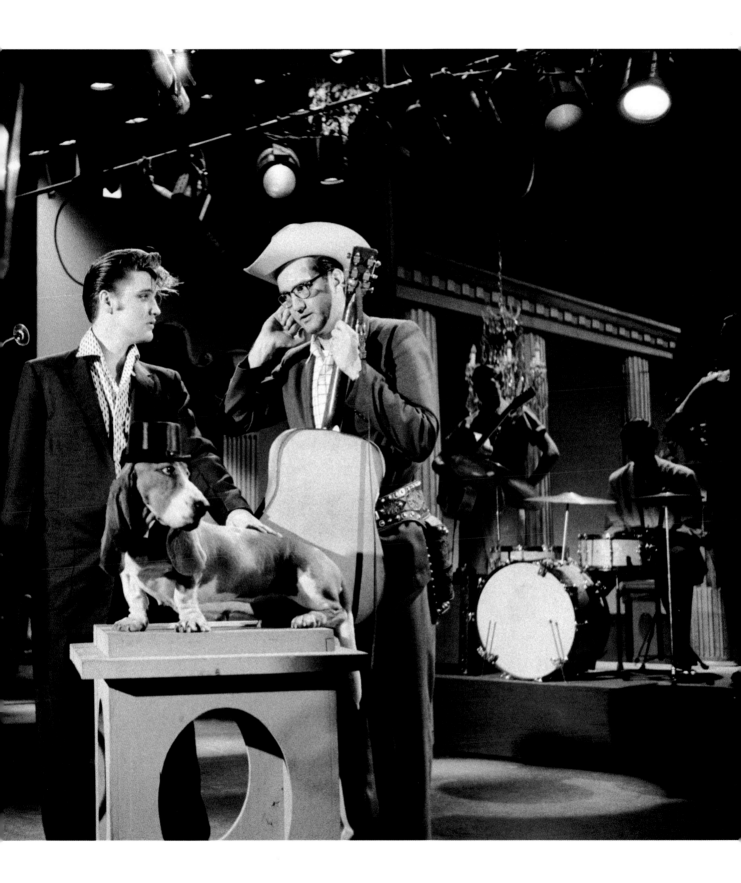

...He would listen respectfully backstage to criticism from agents that wanted him to contain his movements on stage. But once Elvis got on stage, he always did it his way. He really did it his way.

— Alfred Wertheimer

Critics proliferated. But calling Elvis vulgar or rebellious didn't stop fans. It attracted them.

Elvis transcended Allen's constraints, his music and stage presence—both pure art—held the audience in his thrall.

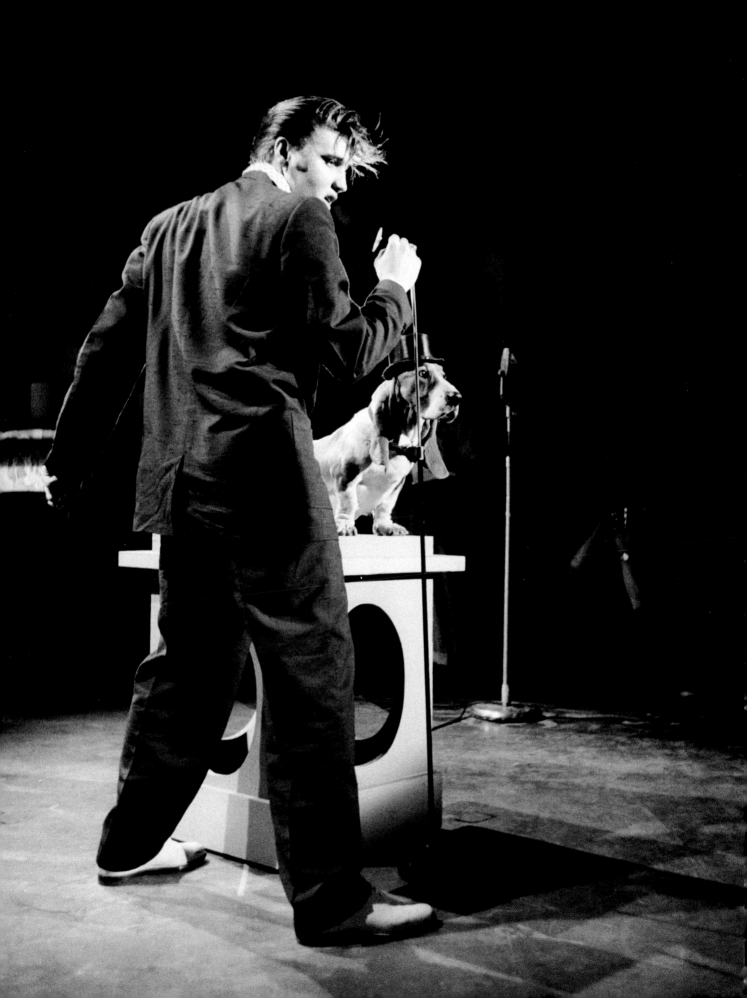

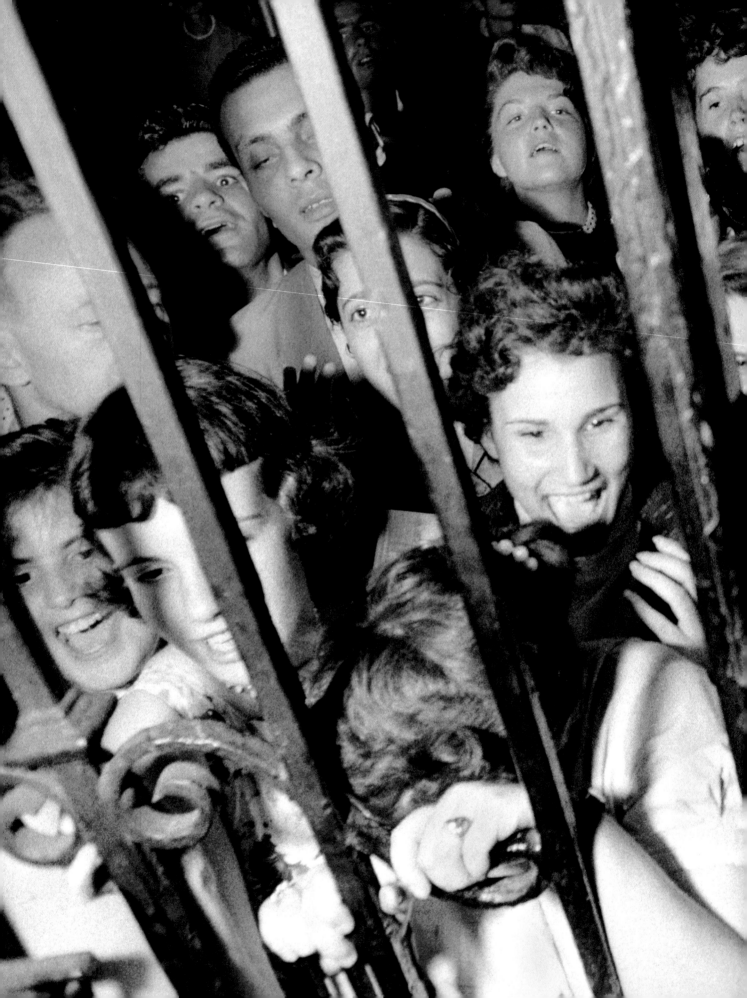

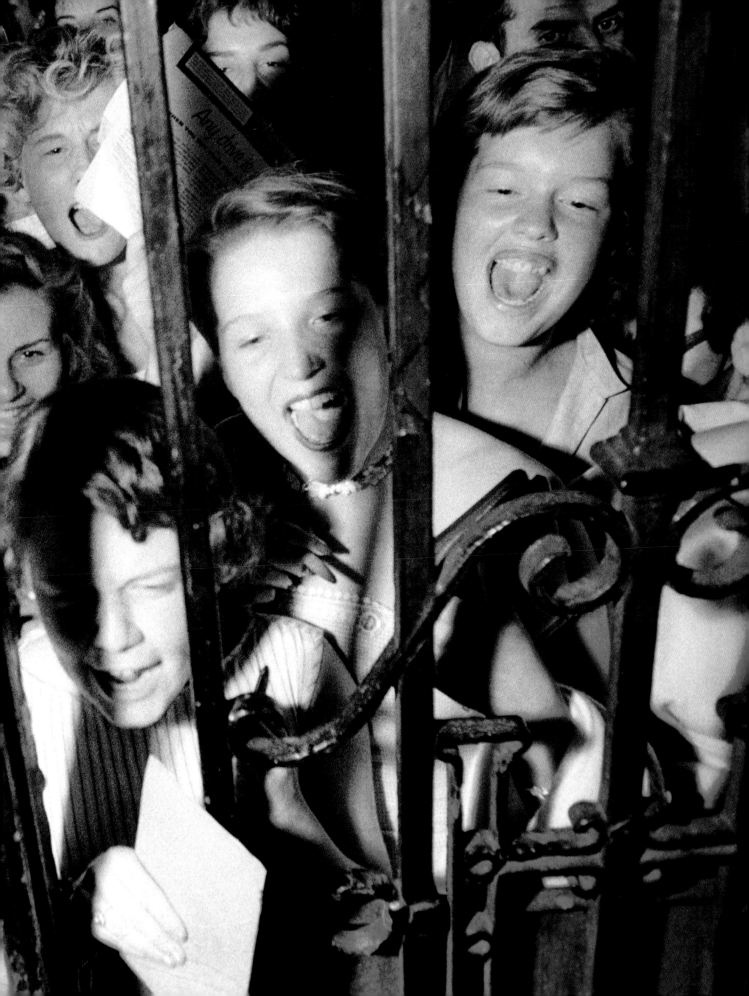

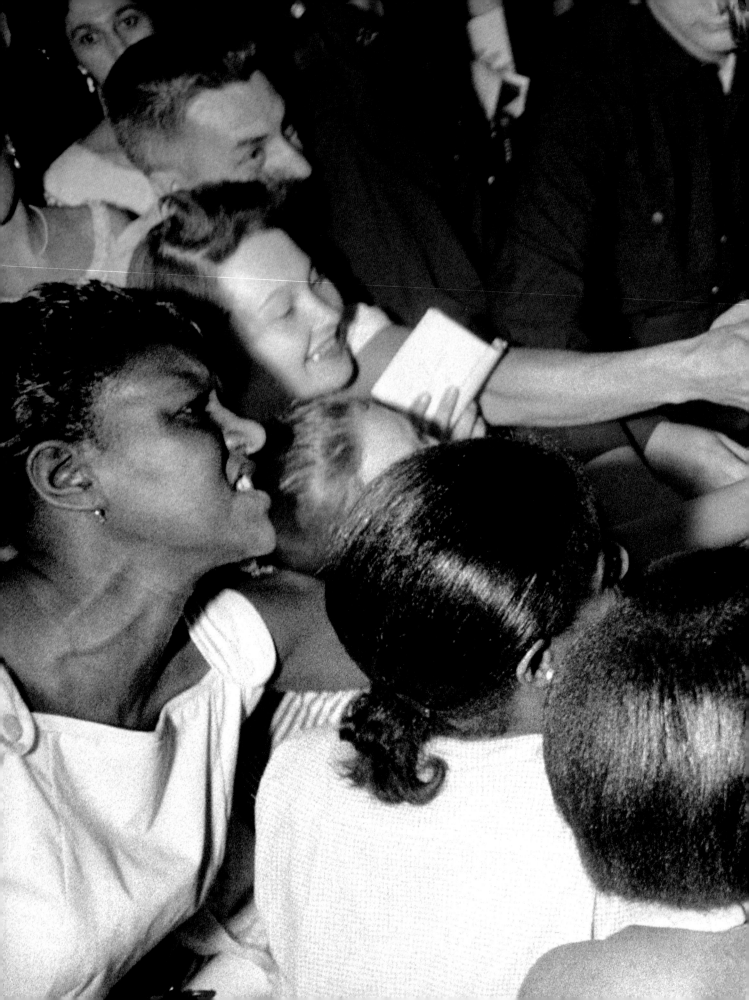

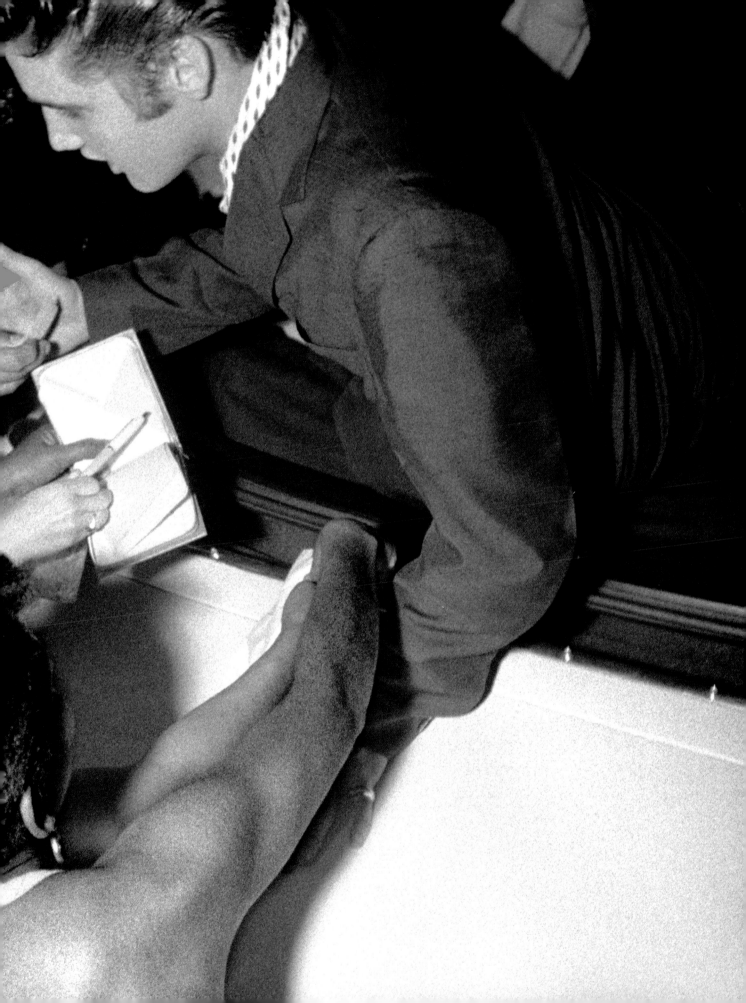

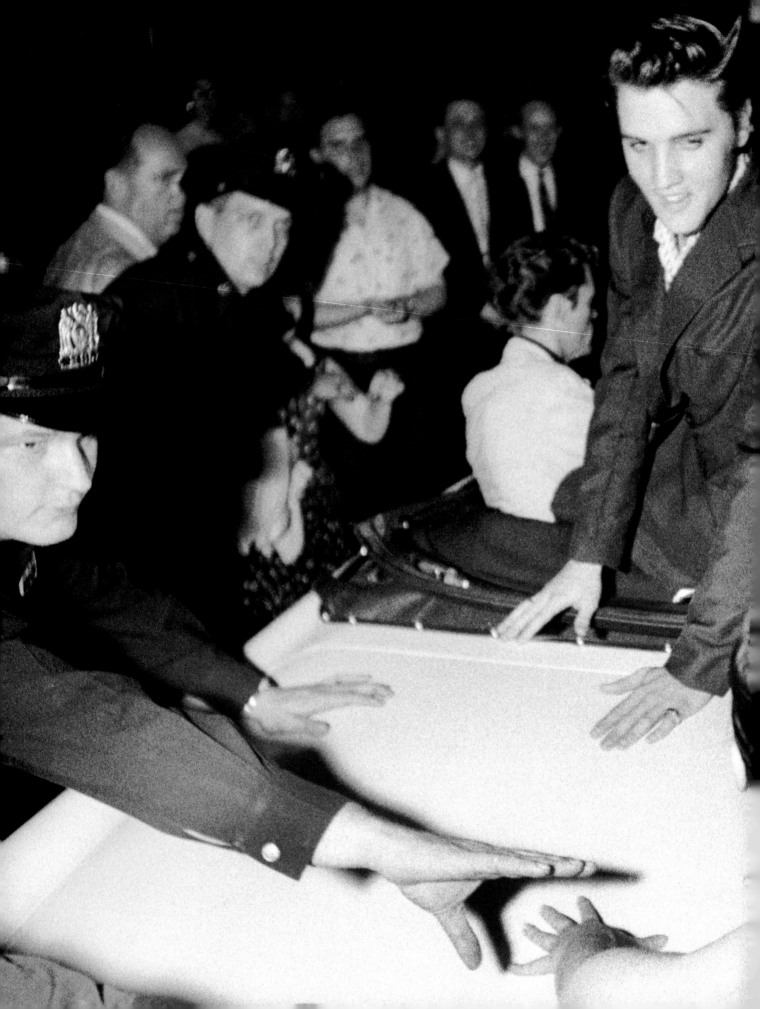

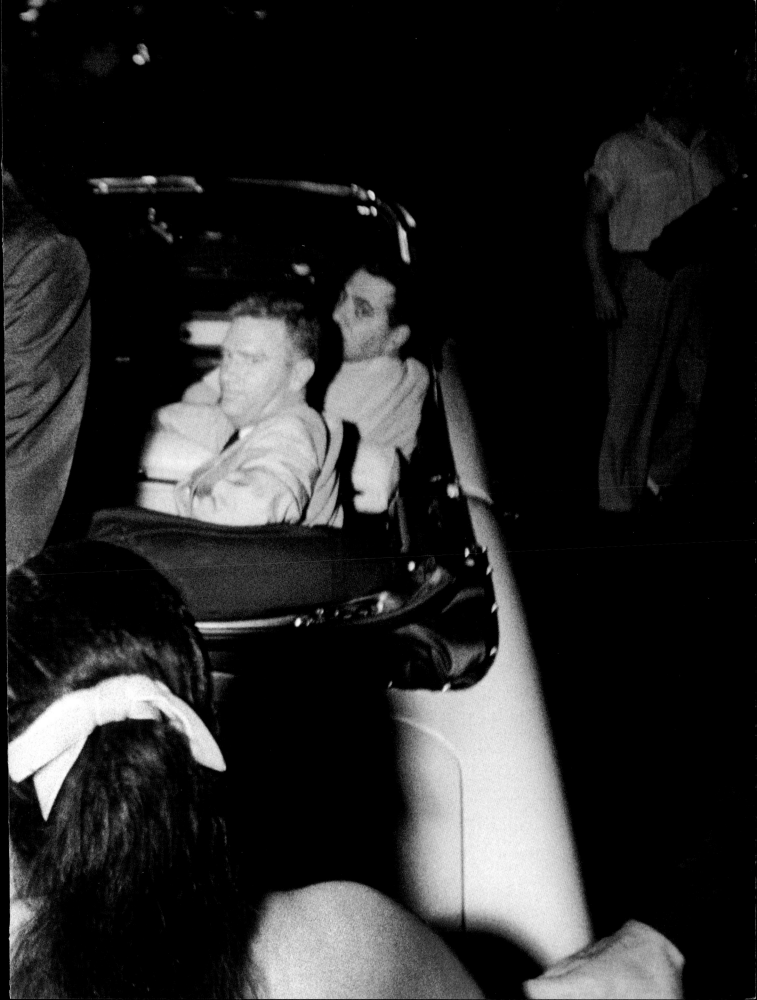

July 2, 1956. The Seminal Recording Session,
New York City.

The RCA recording session began with "Hound Dog."
Two long hours into the session, only after the thirty-first
"take" did Elvis finally grin and say, "This is the one."

Notorious for his studio work ethic and perfectionism,
Elvis controlled his art.

With the A side done, it was on to the B side. Elvis riffled
through a stack of demos and listened on the 14-inch
studio speaker. When he heard "Don't Be Cruel," he said,
"Something I like about that one."

*He went over to the piano and gathered his Jordanaires around him to
arrange the song on the spot. D. J. Fontana was at the drum set behind
the piano. When they felt as if they had something, everyone went back
to their regular positions at the microphones to begin recording.*
— Alfred Wertheimer

"Hound Dog" and "Don't Be Cruel" both hit #1 on the
charts, the first and only time it would ever be achieved by
a single record.

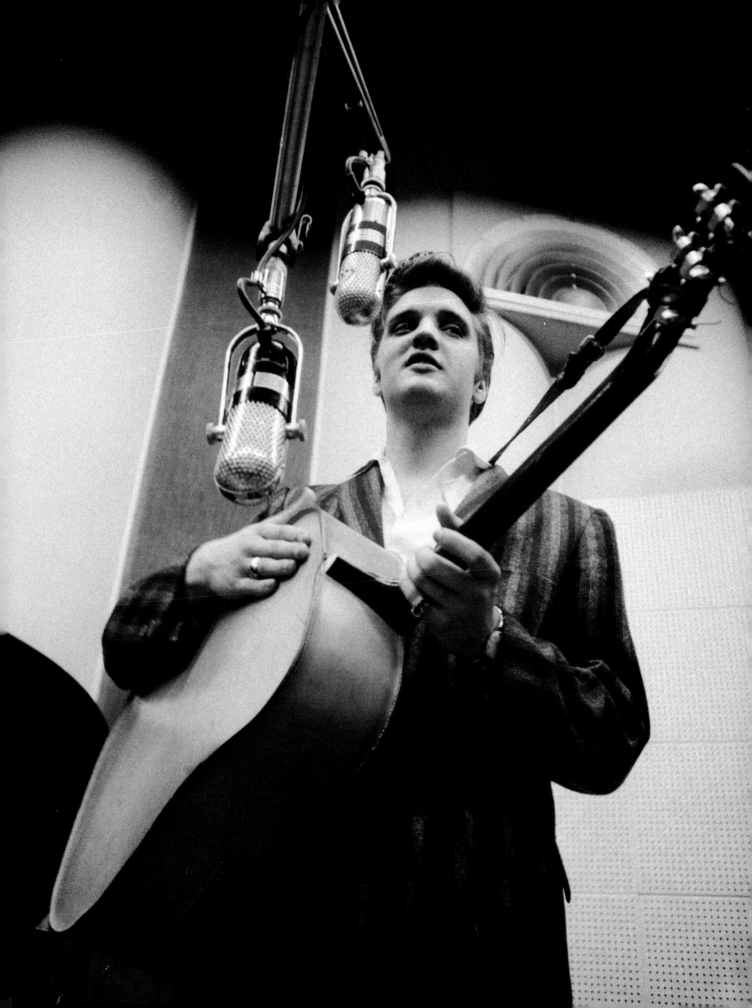

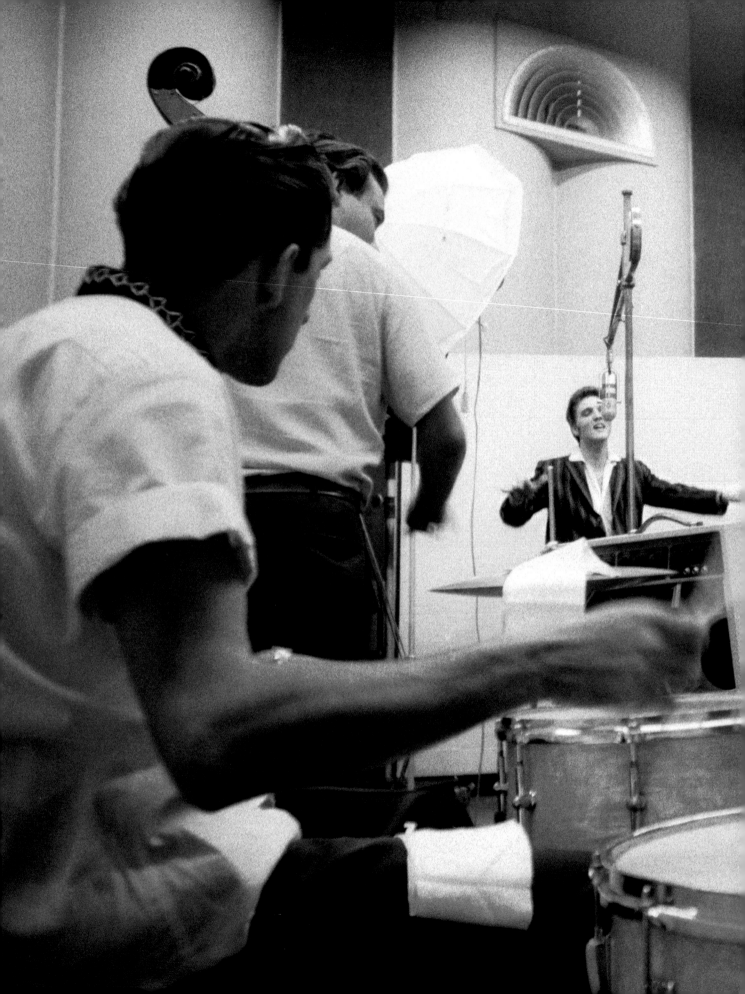

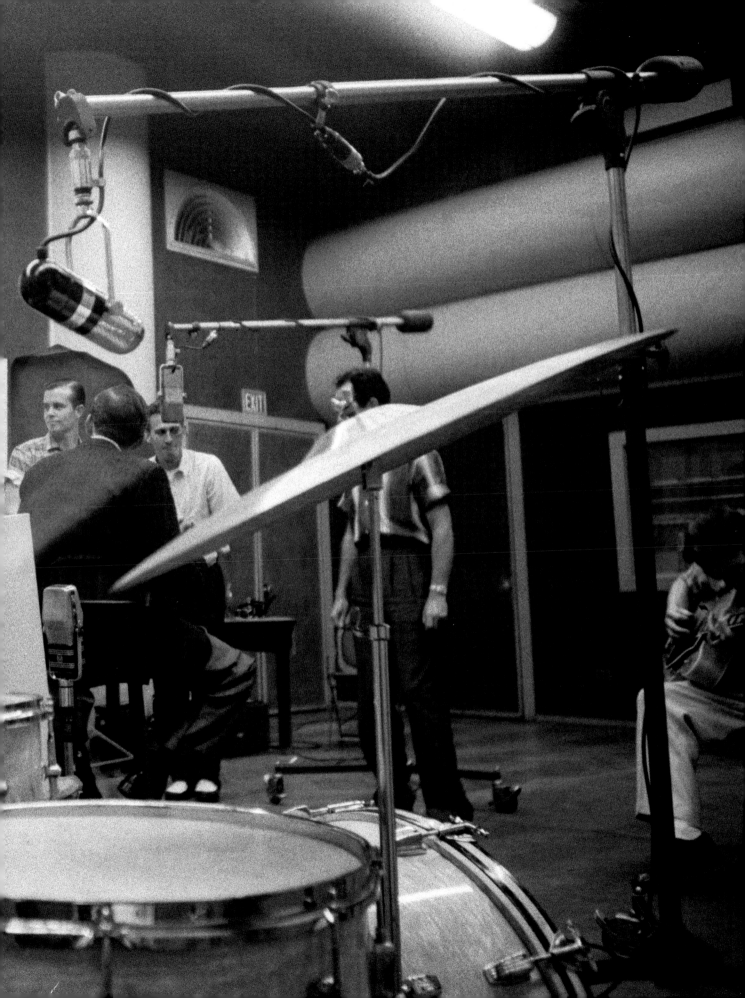

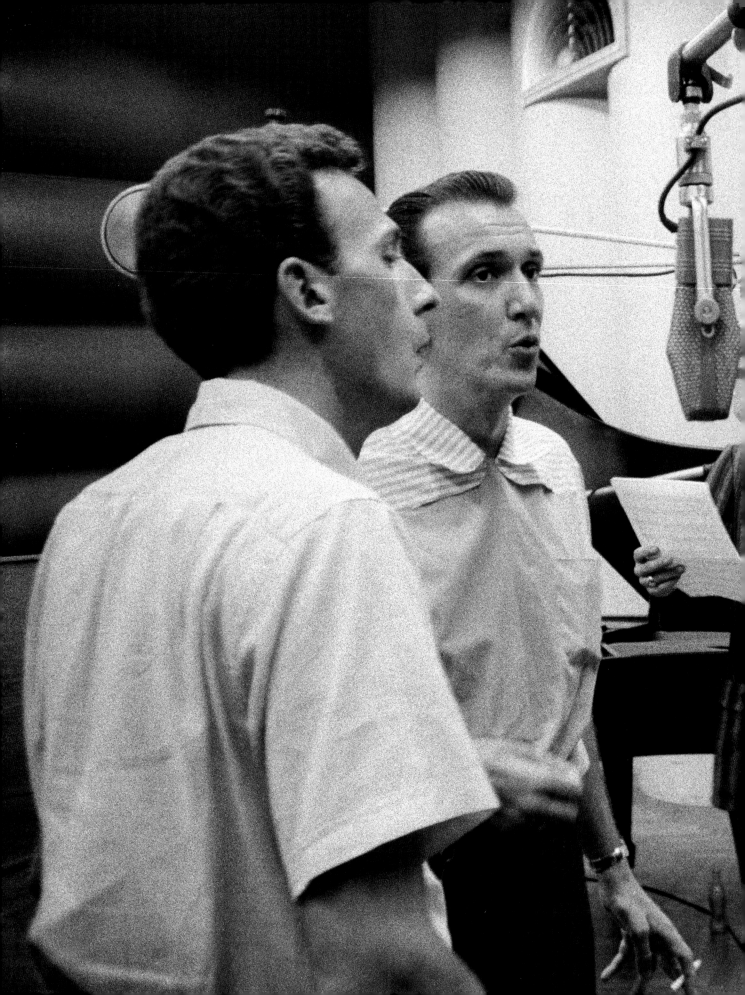

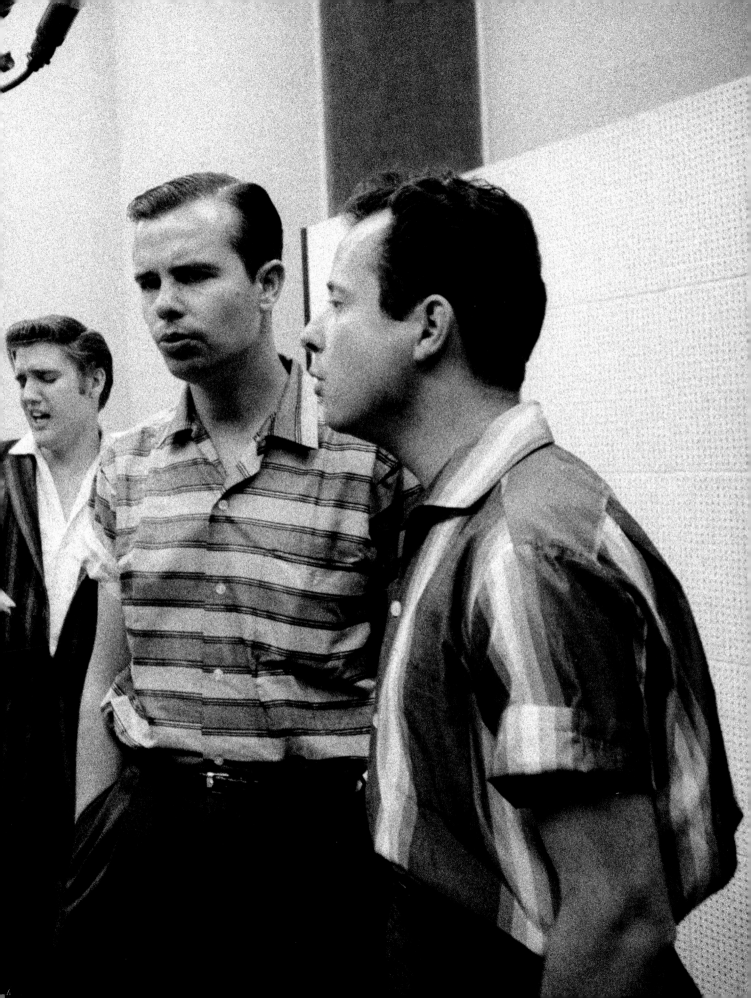

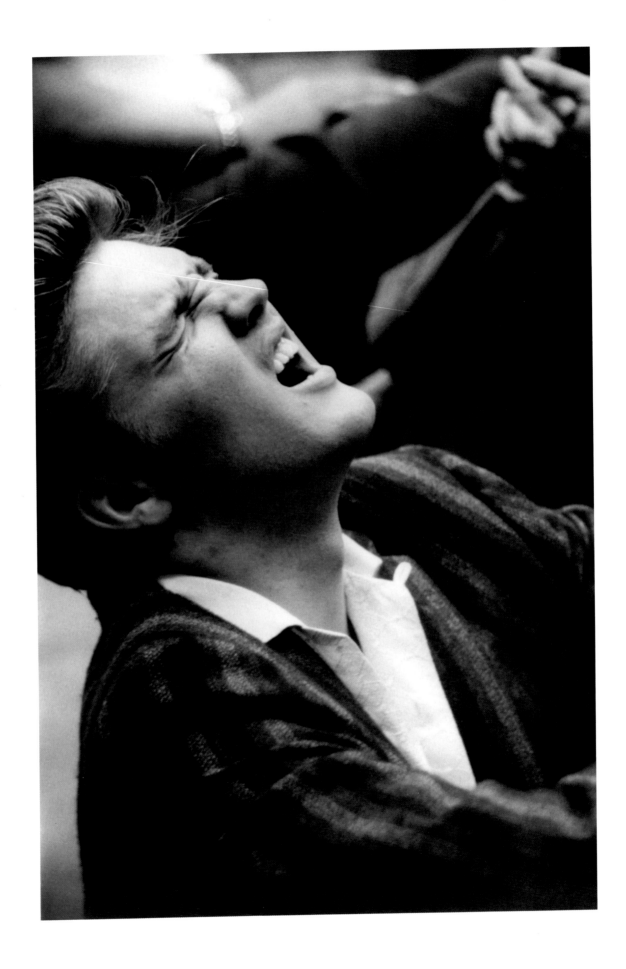

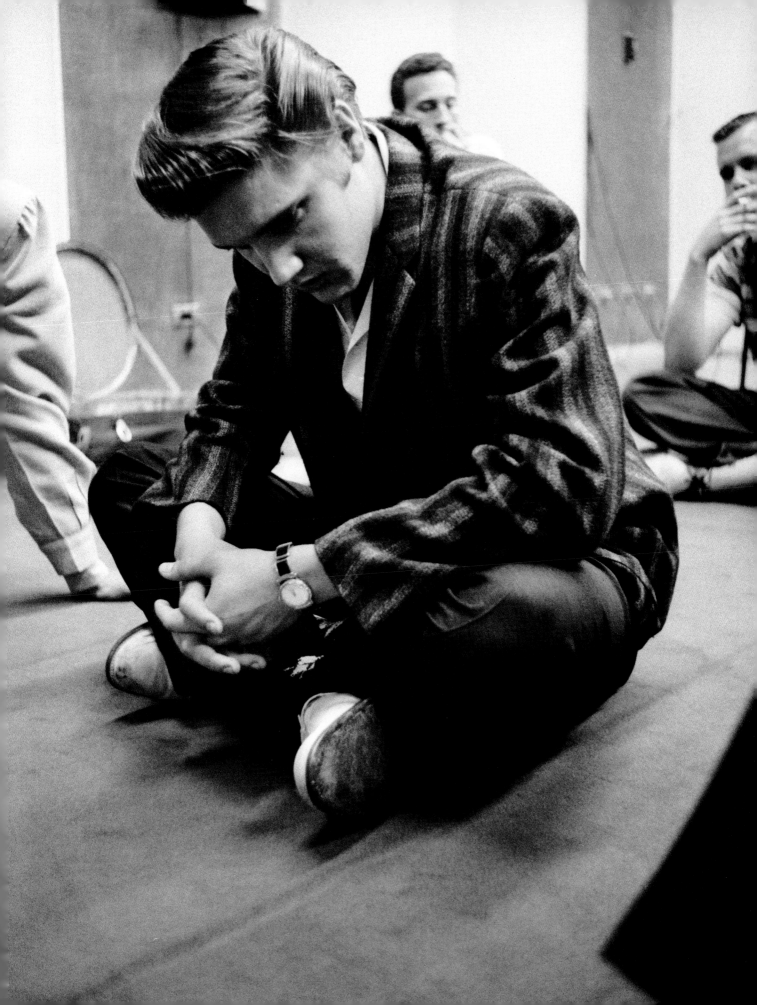

July 3, 1956. New York to Memphis.

The TV appearances had stoked Elvis's fame and mobilized his fans. Yet on this trip home to Memphis he was still remarkably alone.

Traveling by train with a small entourage, virtually unrecognized, Elvis could mix unnoticed with everyone else, family and strangers, black and white, an experience unimaginable just days later in Elvis's career, or in the high-octane celebrity world Elvis ushered in.

The train rolled through small towns, cities, and farmlands. Elvis passed the time listening to the records he had just cut, reading magazines, looking out the window, waiting.

The train made passage through an America on the cusp of massive social change—sparked by people as different as the unassuming Rosa Parks, who helped ignite the modern civil rights movement, and New York poet, Allen Ginsberg, whose "Howl" celebrated the emerging anti-establishment youth culture of the beat generation.

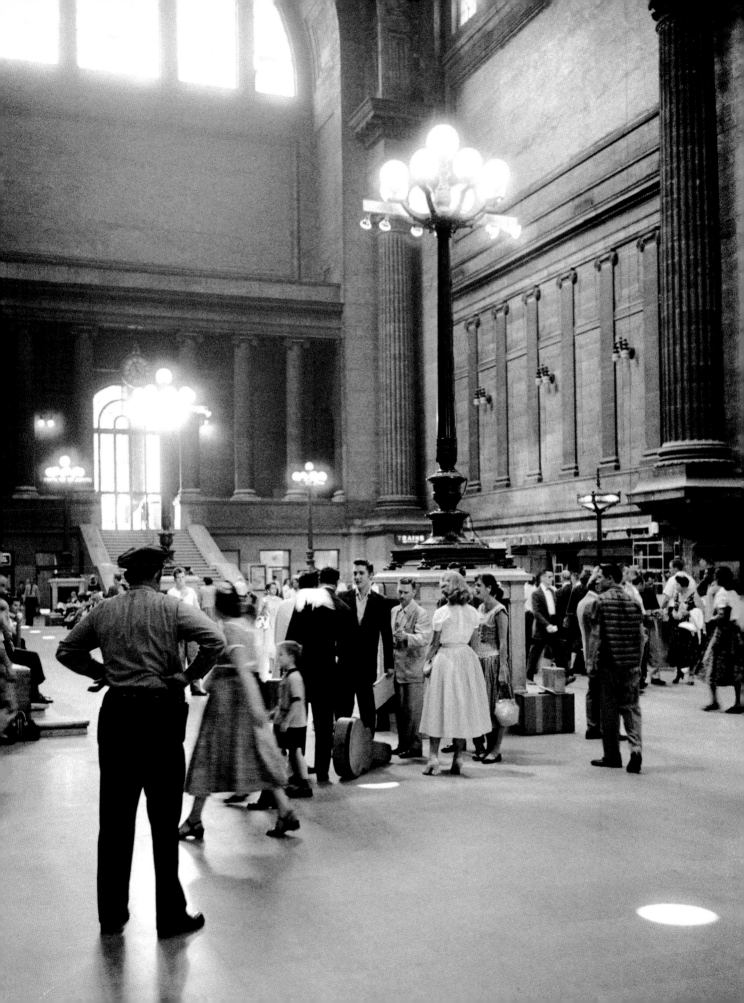

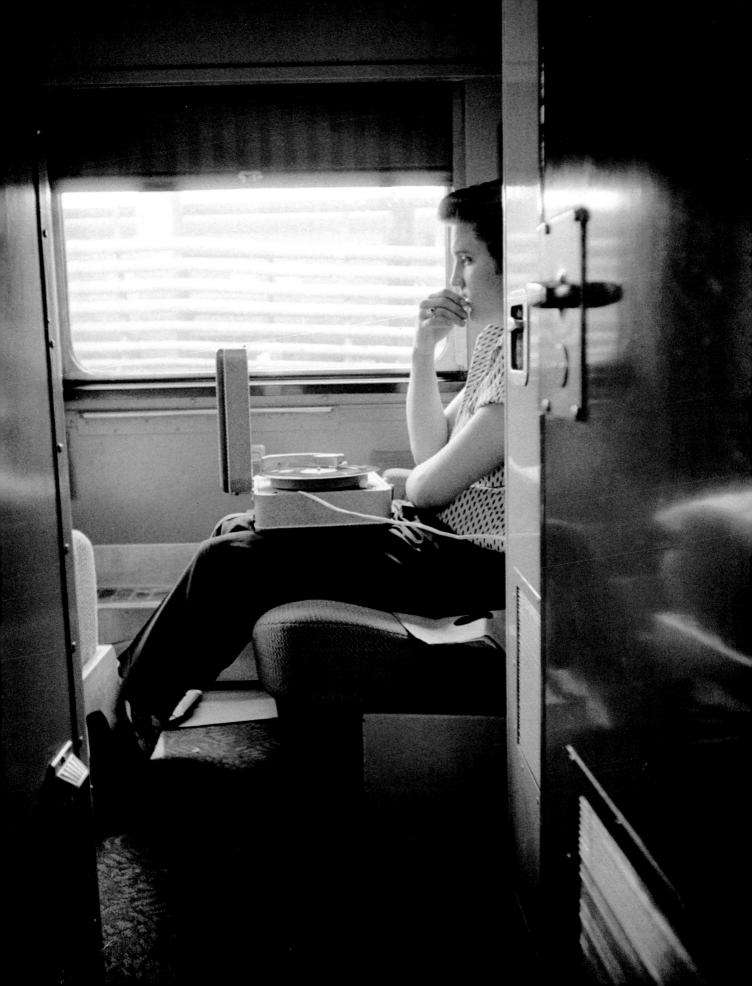

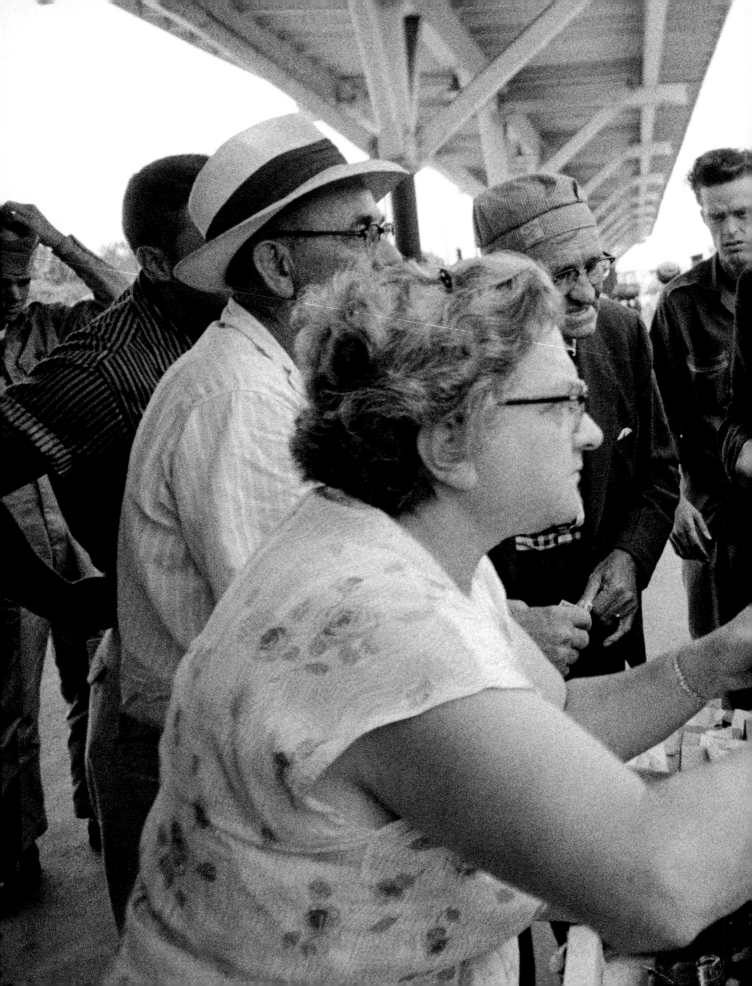

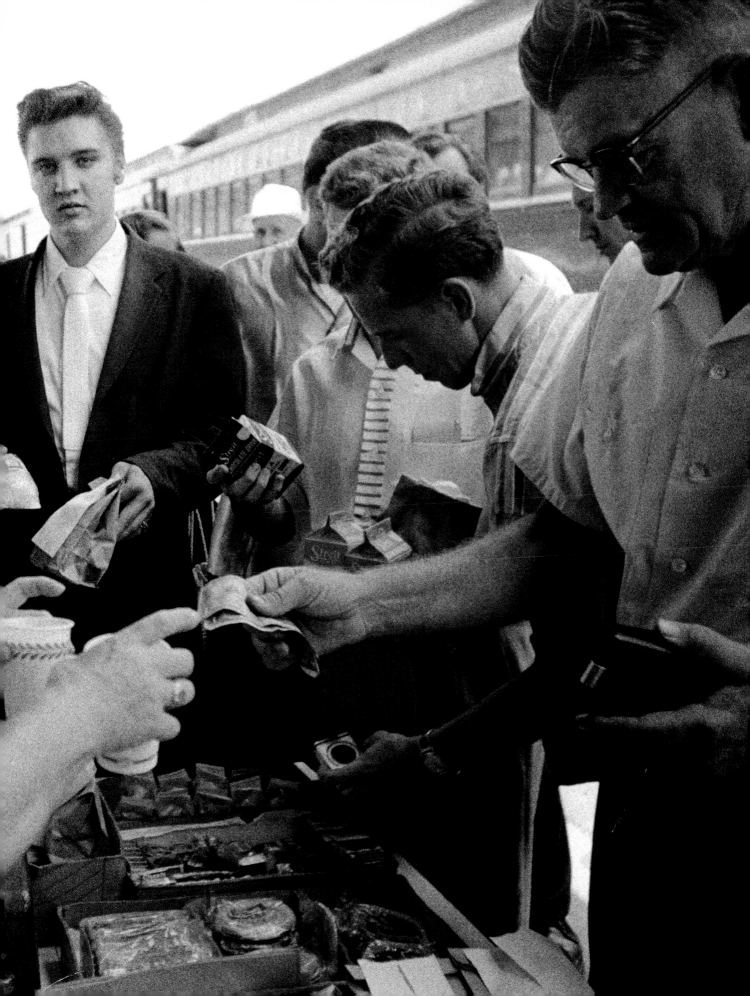

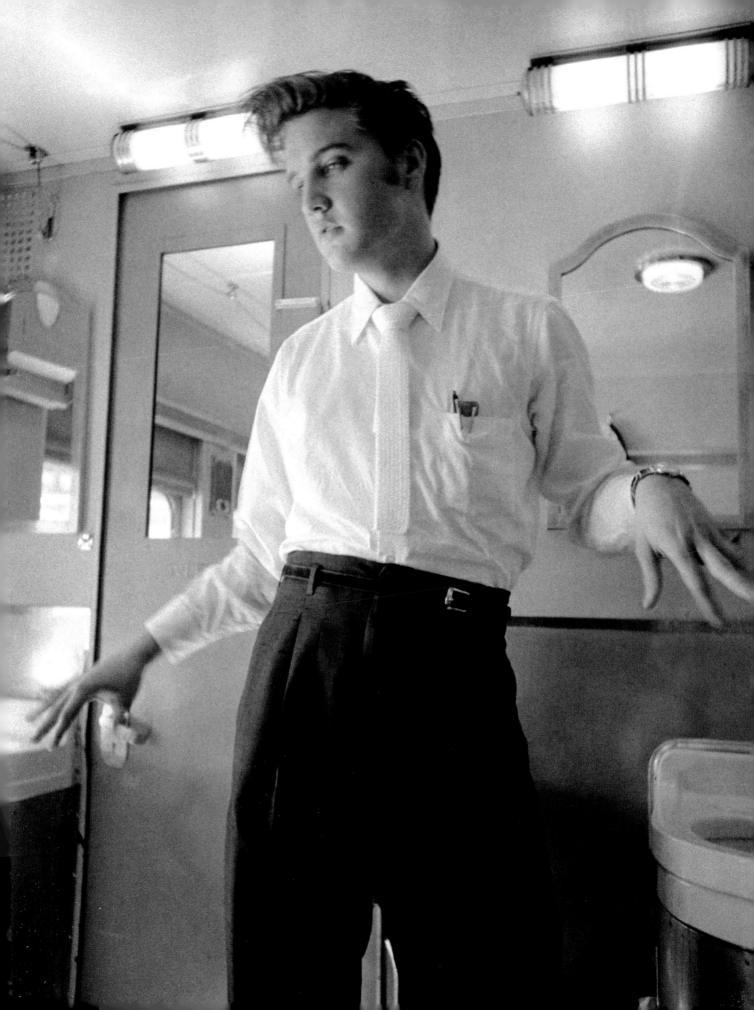

"Separate but equal" as social doctrine was still a fact of life in 1956, but Elvis's music embraced the sounds of a more inclusive America.

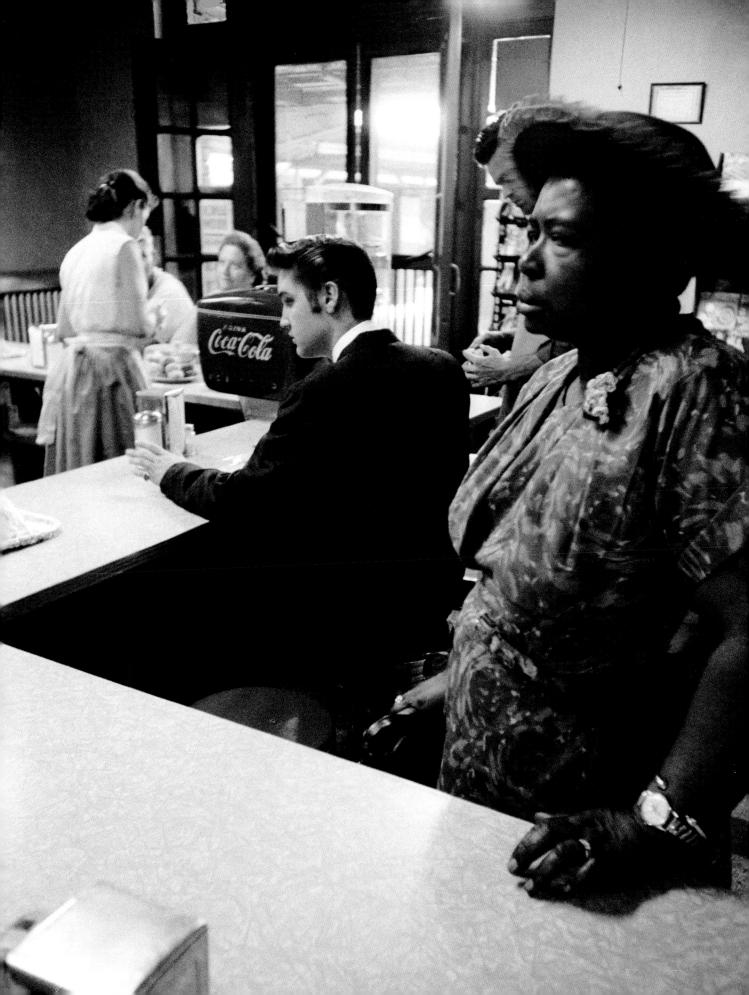

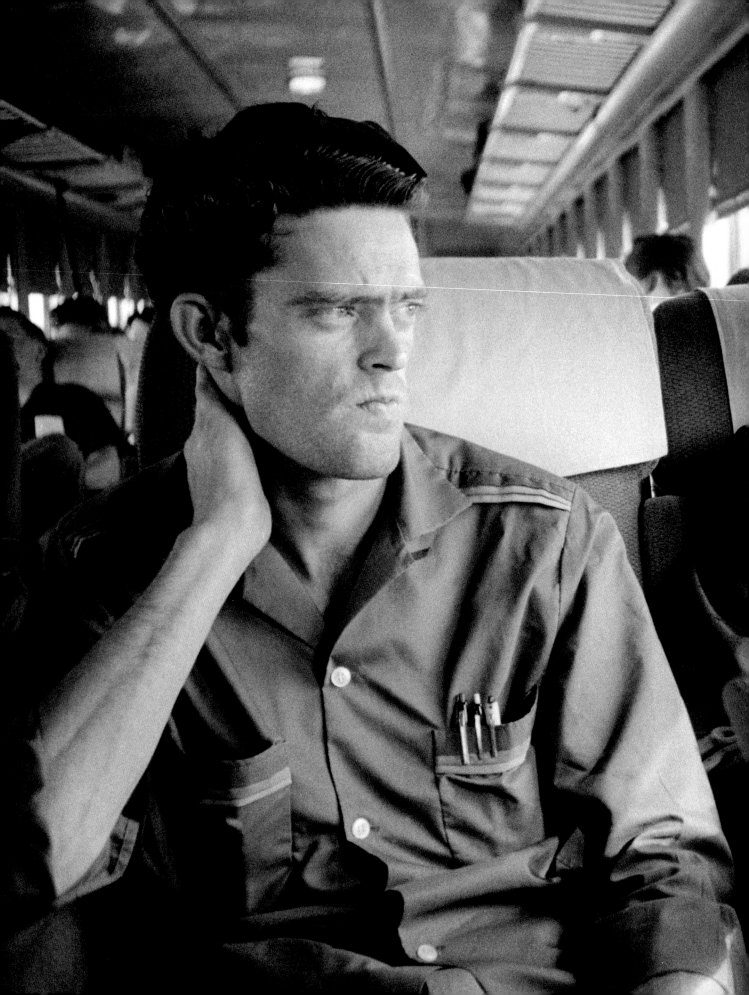

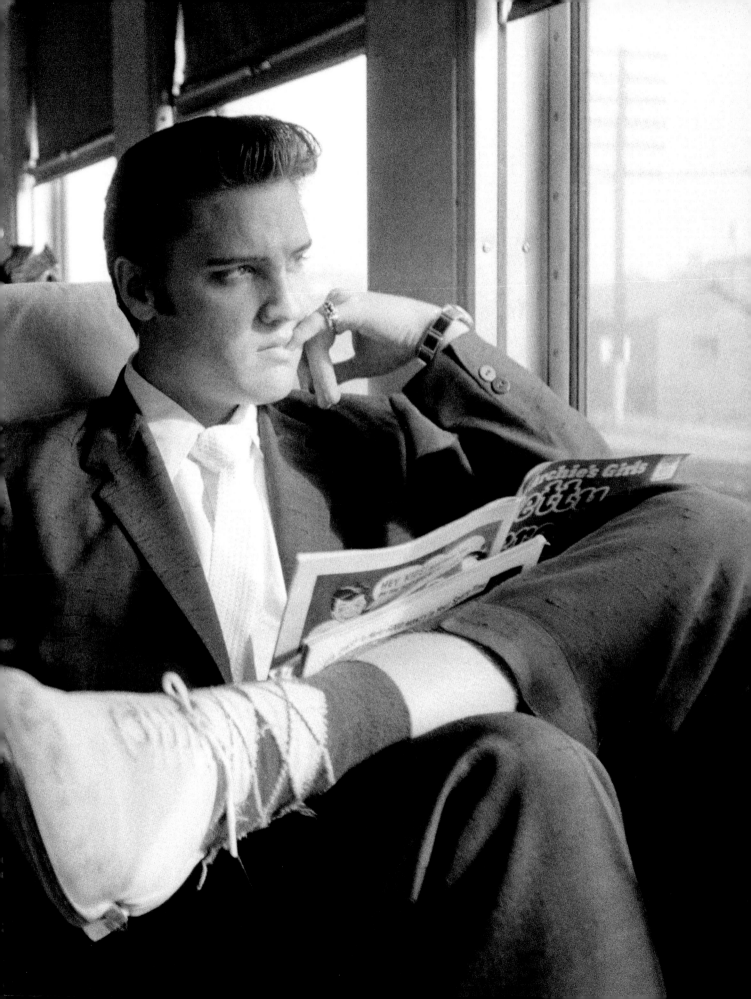

Fully awake now toward the end of this long and tedious train ride, Elvis began freshening up… We hadn't reached Memphis yet but he headed for one of the exits. Someone handed him the quick acetate cuts of the recording session.

The Colonel [Colonel Tom Parker, Elvis's manager] finally roused himself from his nap and was talking to the train conductor, who got on the phone to the engineer. "We have somebody who wants to get off the train. Can we make a short stop at White Station?"

The Colonel approached Elvis. "Don't forget to give your folks my regards."

— Alfred Wertheimer

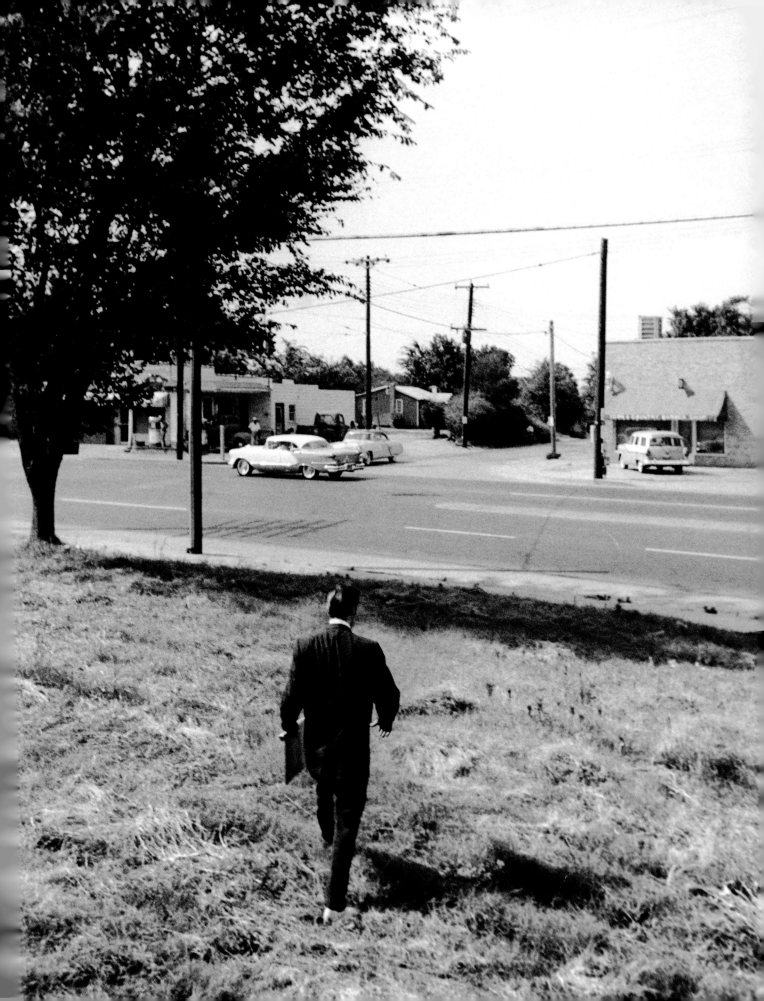

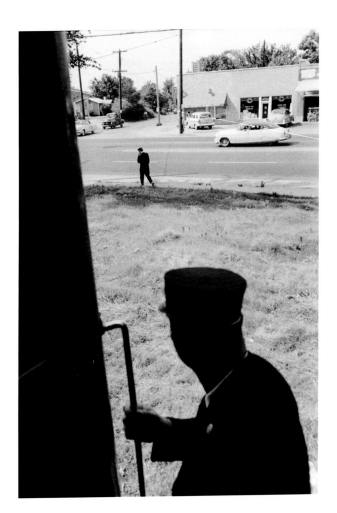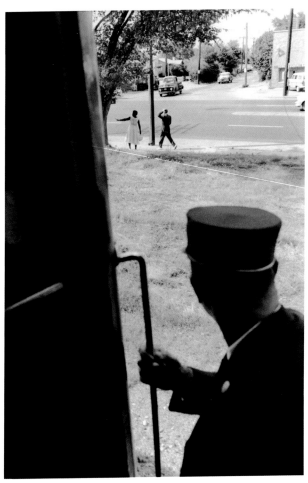

The stop was walking distance from Elvis's home on
Audubon Drive. Anxious to get there, he would save
an hour by skipping the ride to the main terminal in
Memphis and taking a taxi back to the suburbs.

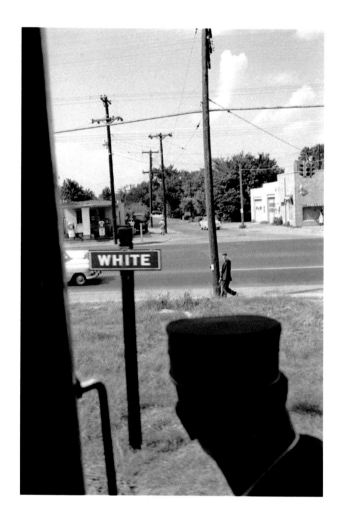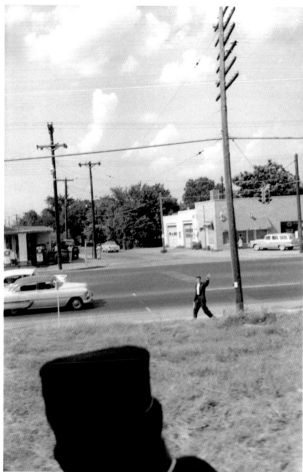

He asked directions from a passerby. He turned to
wave good-bye. He set off for home. It would be
among the last uncomplicated stops on Elvis's journey
into stardom.

July 4, 1956. Home, Memphis.

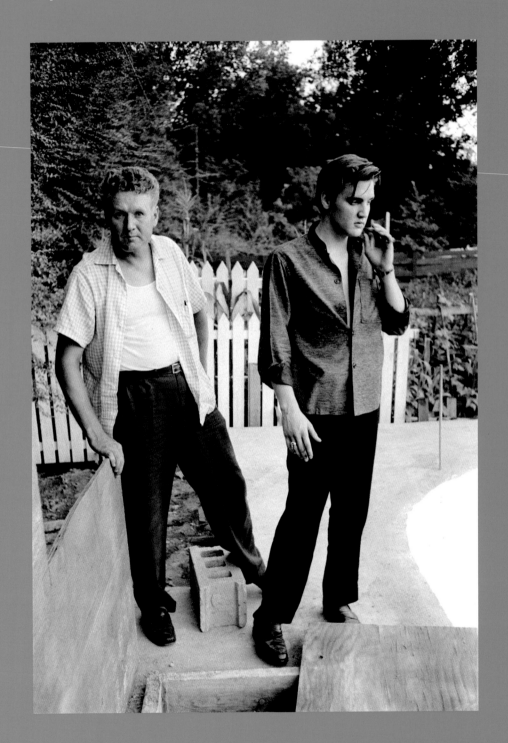

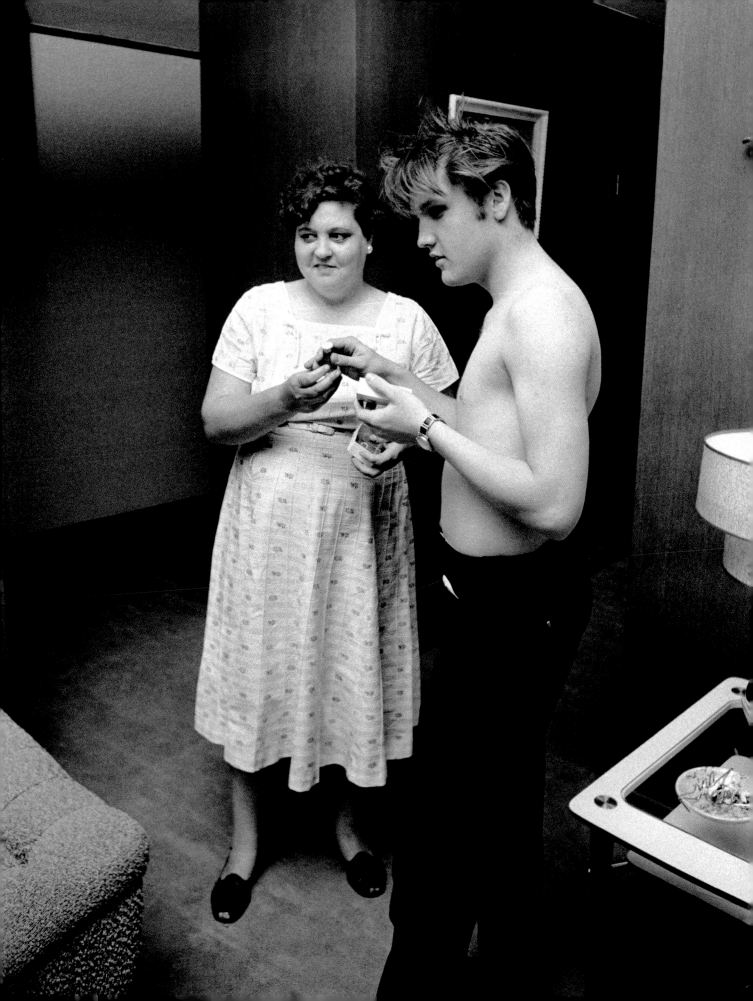

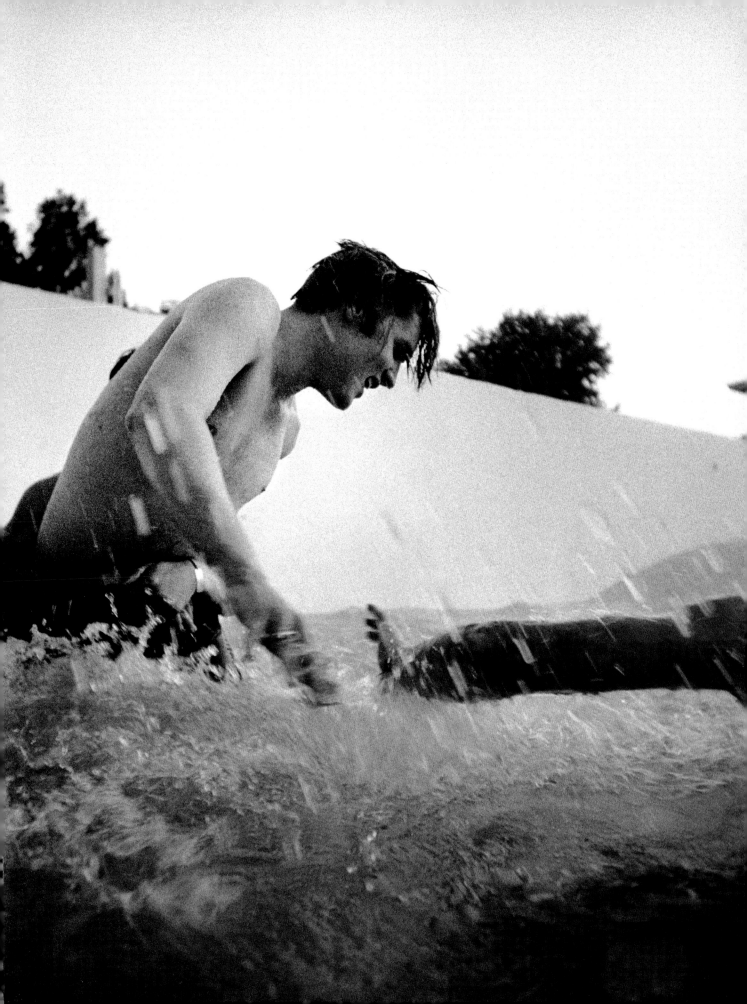

Just out of the pool and still shirtless, Elvis played his recordings for his former high-school sweetheart, Barbara Hearn.

They sat there quietly, focusing on the music. When the disc had been played, Elvis looked up and she told him how nice the songs were. He asked her to dance with him to the music, which she did. Then he tried to give her a kiss but was unsuccessful.
— Alfred Wertheimer

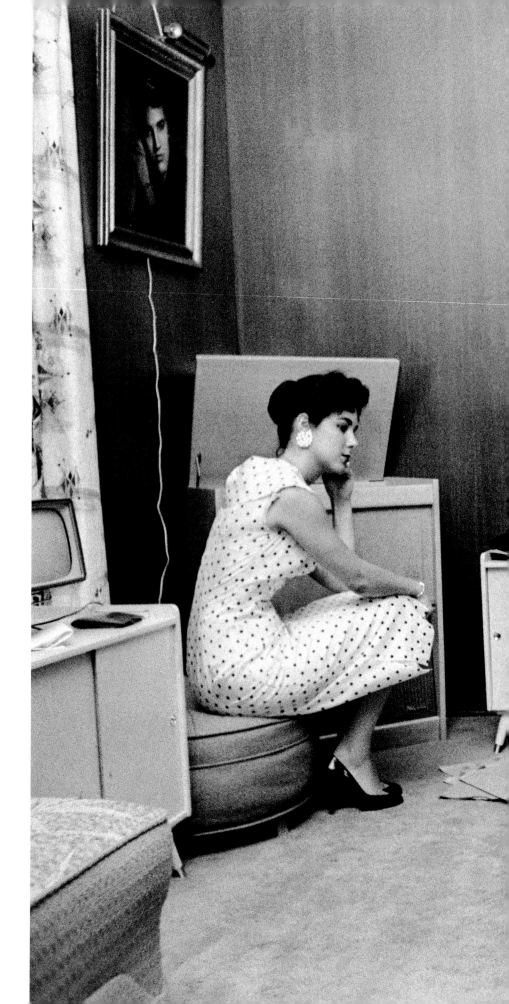

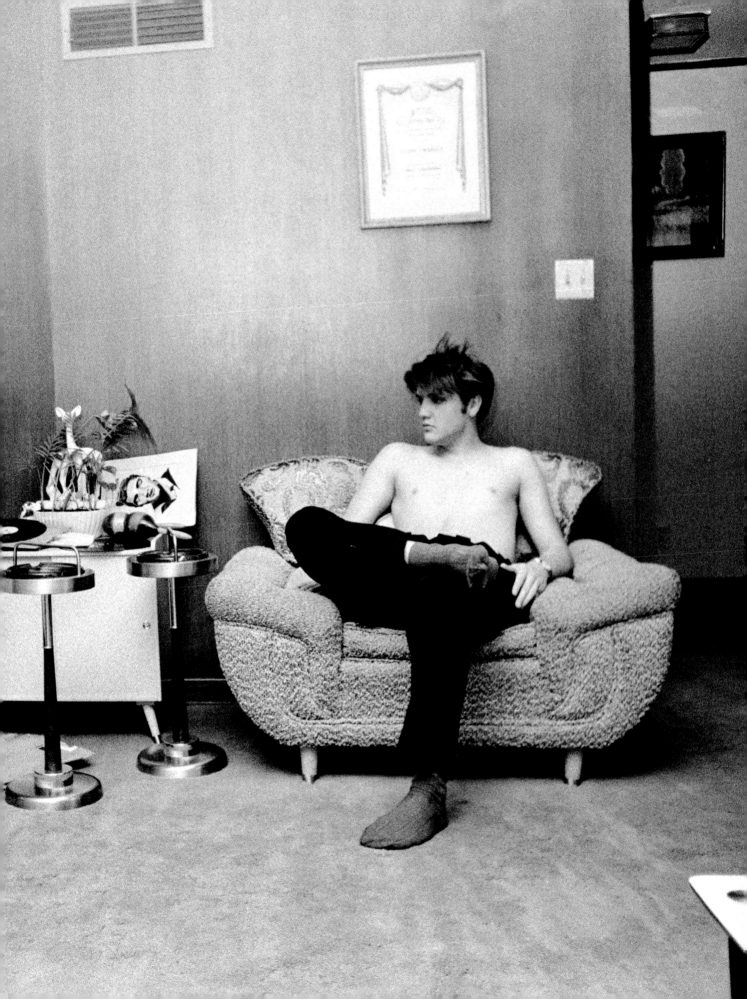

Elvis admired two of the biggest movie stars of the
mid-fifties, Marlon Brando and James Dean. Both
were transformative postwar Hollywood figures—
young, defiant, and determined to cut their own paths.

The motorcycle symbolized that rebel spirit—with its
speed and chrome, it was America on two wheels.

And Elvis loved it.

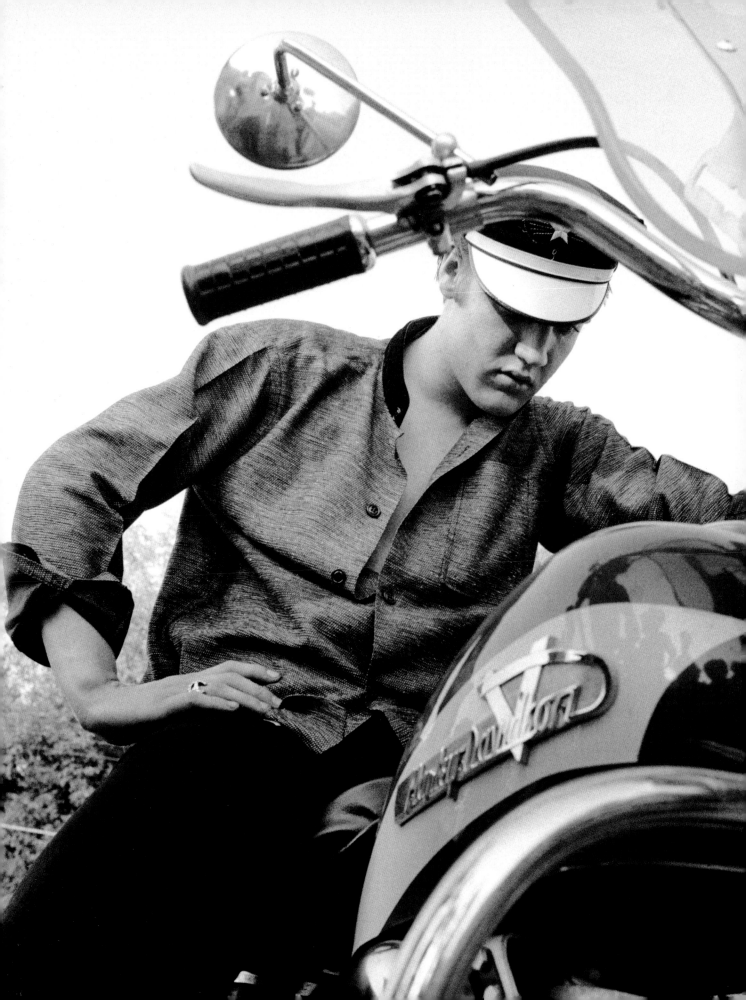

The evening of July 4th, the same day he returned home from New York City, Elvis performed a concert at Russwood Park in Memphis. A phalanx of local police and Shore Patrol officers guided Elvis through a surging wall of screaming fans. Elvis, dressed all in black, took the stage.

Since Elvis had been seen just three days earlier on The Steve Allen Show, *where he was tightly scripted into a tuxedo singing to a basset hound, he started this night's performance off with a statement. "Tonight, you're going to see what the real Elvis Presley is all about." Before you knew it, he was gyrating all over the stage in his signature way. The audience loved it. Thousands of people screamed and hollered for their hometown boy who had made it in the big time. Elvis felt good that night, and so did I.*

— Alfred Wertheimer

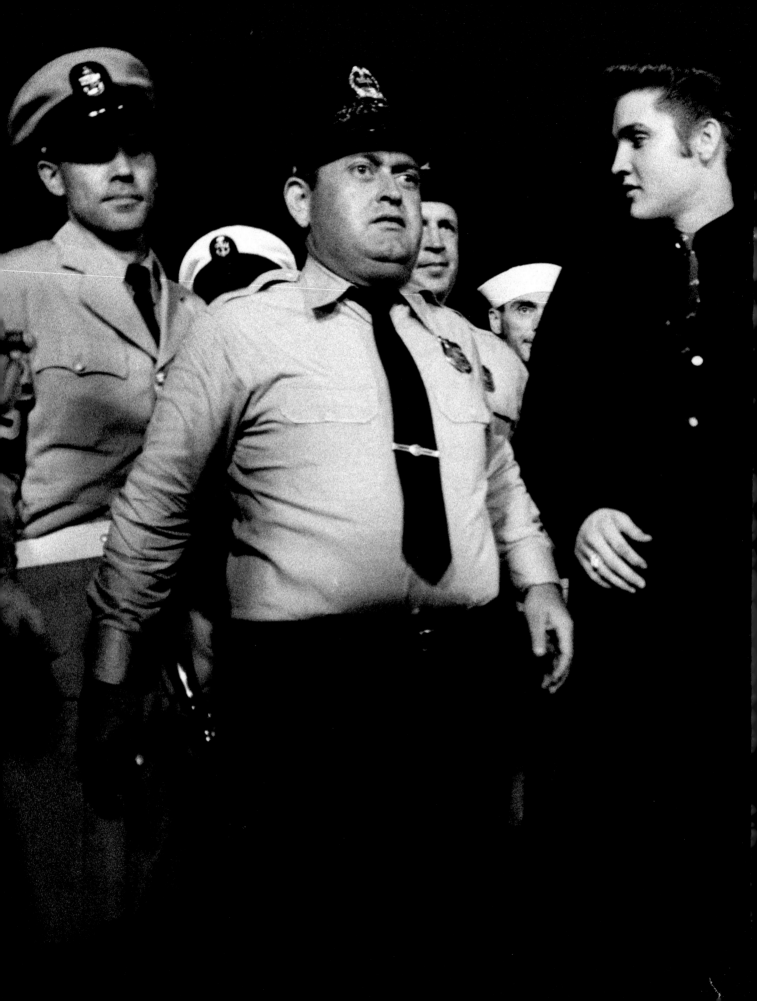

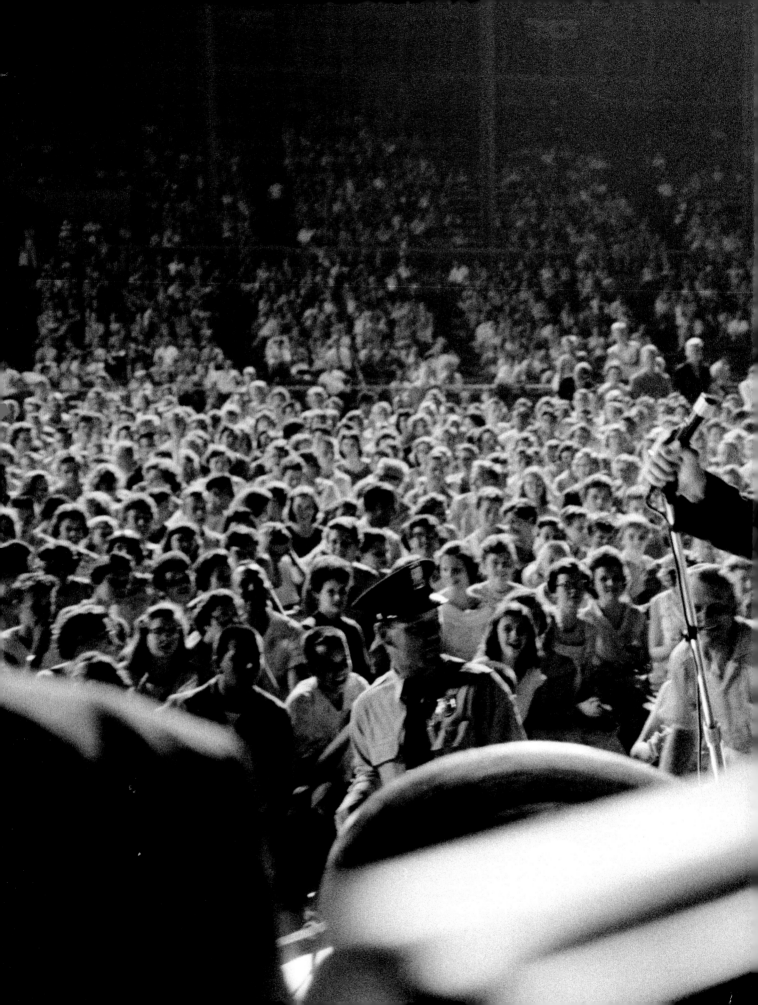

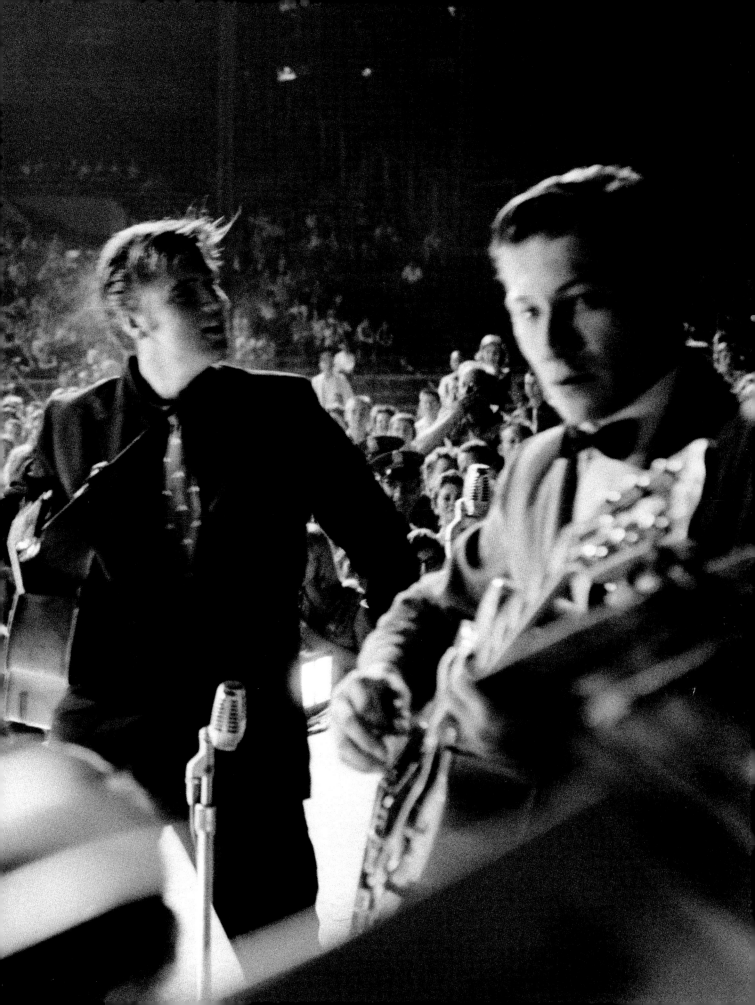

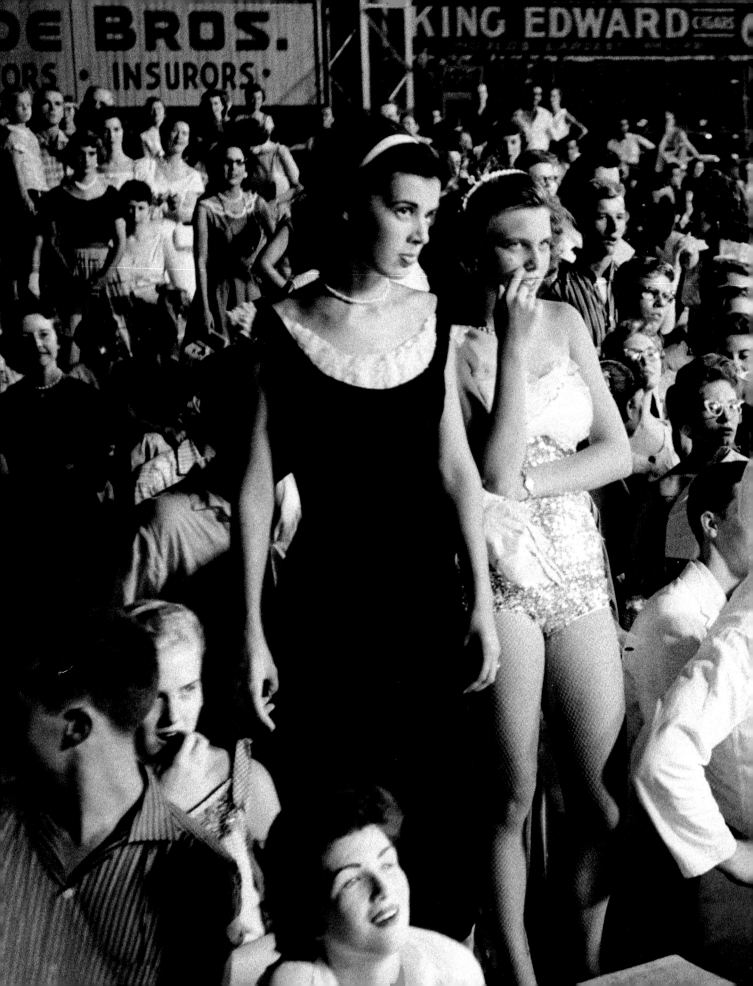

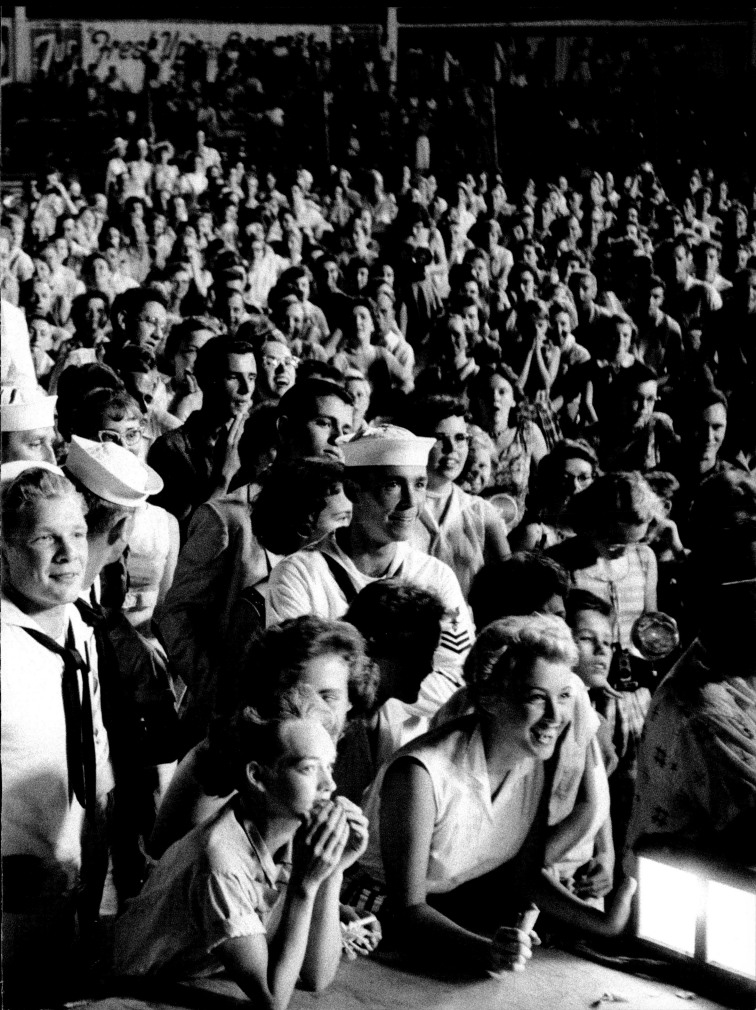

Although flashbulbs were going off constantly during the performance, I knew they wouldn't affect my still shots. Except for one… When I developed the film, I discovered a shot of Elvis with a magnificent spray of light in front of him. Not strong enough to reach the stage, the flash in the audience highlighted the back of about thirty rows of heads as well. That random flash was in perfect sync with my shutter opening.… When I saw the photograph, it represented for me a wonderful piece of luck. Instead of ruining the frame, it actually enhanced it. A "Starburst" was born.

— Alfred Wertheimer

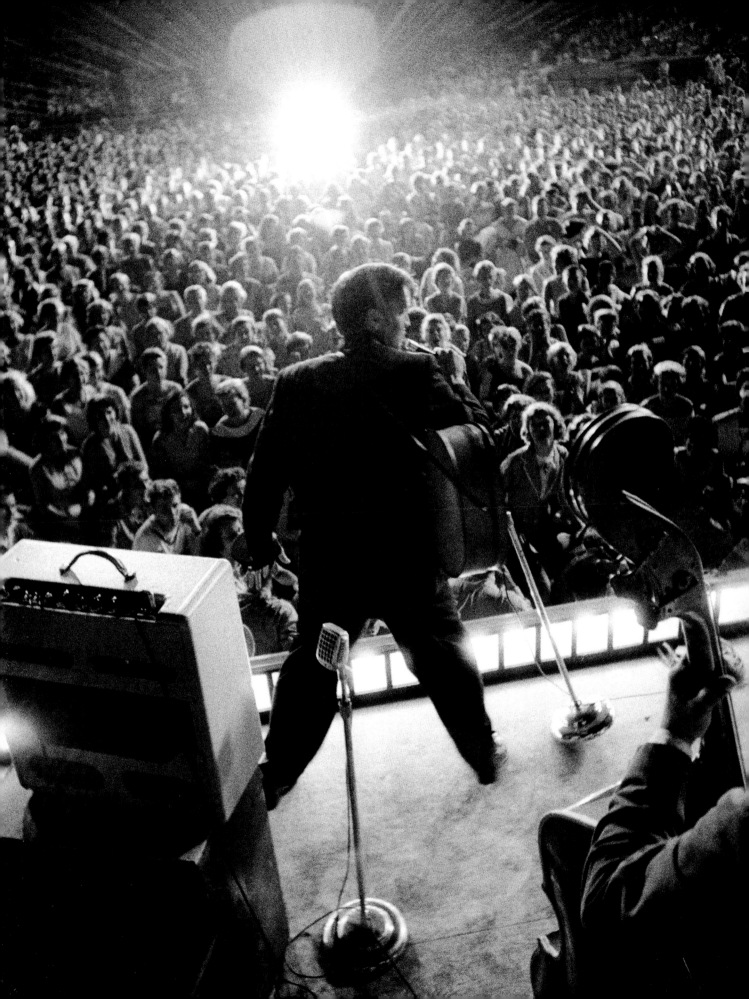

Index of Photographs

Going Home
Elvis on the Southern Railroad
between Chattanooga and
Memphis, Tennessee, July 4, 1956
PAGE 21

Entering The Warwick
Between the afternoon rehearsal
and the evening performance
of *Stage Show*, hosted by Tommy
and Jimmy Dorsey, Elvis returns
to his hotel.
New York City, March 17, 1956
PAGE 23

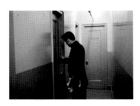

Entering His Room at The Warwick
Elvis enters his hotel room
to rest and freshen up before
the evening nationwide live
television performance.
New York City, March 17, 1956
PAGE 24

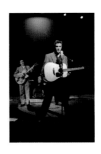

Elvis Reading Fan Mail
Once inside his suite at The
Warwick, Elvis finds an envelope
containing dozens of fan letters,
which he proceeds to read and
then tears into small pieces.
New York City, March 17, 1956
PAGES 24–25

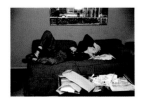

Elvis Lies On His Fan Mail
Tired from the afternoon
rehearsal for *Stage Show*, Elvis
naps on his unopened fan mail.
New York City, March 17, 1956
PAGES 26–27

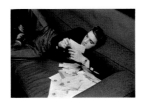

A-Frame
Elvis awaits the director's cue to
sing "Heartbreak Hotel" during
the afternoon rehearsal. Scotty
Moore, Elvis's guitarist, is to
his right.
CBS Studio 50, New York City,
March 17, 1956
PAGE 29

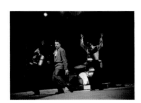

Four Fingers
Elvis and his band in a
performance of "Blue Suede
Shoes" on the Dorsey Brothers's
Stage Show. Scotty Moore,
guitar; Bill Black, bass; and
D. J. Fontana, drums.
CBS Studio 50, New York City,
March 17, 1956
PAGES 30–31

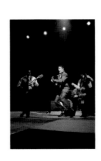

Jump
Elvis and his band in a
performance of "Blue Suede
Shoes" on the Dorsey Brothers's
Stage Show. Scotty Moore,
guitar; Bill Black, bass; and
D. J. Fontana, drums.
CBS Studio 50, New York City,
March 17, 1956
PAGE 32

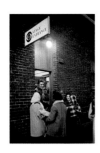

Elvis at the Stage Door
Elvis chats with some very
cold well-wishers who came to
greet him during near freezing
weather the day he appeared
for the fifth time on Tommy
and Jimmy Dorsey's *Stage Show*,
produced by Jackie Gleason.
CBS Studio 50, New York City,
March 17, 1956
PAGE 33

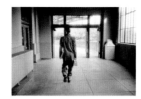

Elvis Did Have a Pelvis
Leaving the Richmond Train
Station on his way to the
Jefferson Hotel with an RCA
portable transistor 7 radio in one
hand and the script for *The Steve
Allen Show* in the other.
Richmond, Virginia,
June 30, 1956
PAGES 36–37

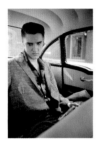

Elvis Gawking in Cab
With his RCA portable
transistor 7 radio blasting away
in the back of a local cab from
the train station, Elvis is about
to leave for the Jefferson Hotel.
He has two performances at the
Mosque Theater that afternoon
and evening.
Richmond, Virginia,
June 30, 1956
PAGE 39

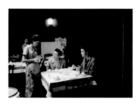

Gentlemen, What Would You Like?
The waitress asked Junior
Smith, Elvis's cousin and "gofer,"
and Elvis what they would
like for lunch in the Jefferson
Hotel dining room. After some
thought, Elvis ordered bacon
and eggs.
Richmond, Virginia,
June 30, 1956
PAGES 40–41

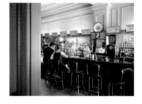

Grilled Cheese 20¢
With his date for the day, whom
he met at the Jefferson Hotel,
Elvis has a bowl of soup at the
hotel coffee shop while showing
her the script for *The Steve Allen
Show*.
Richmond Virginia,
June 30, 1956
PAGES 44–45

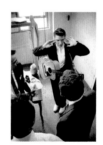

The Noisy Green Room
Elvis tries to concentrate on
rehearsing some songs he will
perform with the Jordanaires,
his backup vocal group. Finding
it hard to concentrate because of
the screaming fans outside,
he finally goes to the window
and asks them to be quiet. After
his request they are silent.
Mosque Theater, Richmond,
Virginia, June 30, 1956
PAGE 46

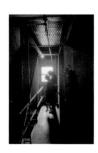

Light at the End of the Tunnel
Two figures in silhouette, one
Elvis, and the other his date
for the day, try to have some
privacy backstage while other
performers are onstage during
"The Elvis Presley Show."
Mosque Theater, Richmond,
Virginia, June 30, 1956
PAGE 47

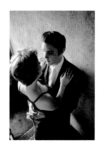

Hold Me Tight
In the privacy of the narrow
hallway under the fire stairs of
the Mosque Theater while other
performers are onstage before
3,000 fans, Elvis concentrates
on his date for the day.
Mosque Theater, Richmond,
Virginia, June 30, 1956
PAGE 48

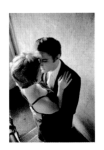

Whispering Softly
In the privacy of the narrow hallway under the fire stairs of the Mosque Theater while other performers are onstage before 3,000 fans, Elvis concentrates on his date for the day.
Mosque Theater, Richmond, Virginia, June 30, 1956
PAGE 48

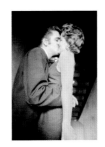

Bent Nose
Elvis is challenged by his date—"I'll bet you you can't kiss me!"—after which she sticks out her tongue. Elvis overshoots the mark on his first try to kiss her and bends her nose.
Mosque Theater, Richmond, Virginia, June 30, 1956
PAGE 49

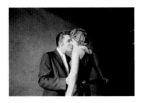

The Kiss
After his first attempt to kiss his date, Elvis cooly backs up a few inches and comes in for a second try, with his tongue slightly out, and barely touches the tip of her tongue. Mission accomplished.
Mosque Theater, Richmond, Virginia, June 30, 1956
PAGES 50—51

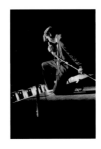

Kneeling at The Mosque
Elvis, on his knee in front of the footlights, sings to his 3,000 mostly female teenage fans, who are delighted by his presence and his music. He leaves them in tears of joy.
Mosque Theater, Richmond, Virginia, June 30, 1956
PAGE 53

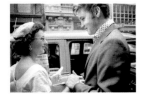

Elvis Greets Fan in White
Having arrived at the Hudson Theater in New York City to perform on *The Steve Allen Show* Elvis is greeted by a female fan who has come all the way in from Long Island to meet her idol.
Outside Hudson Theater, New York City, July 1, 1956
PAGES 56—57

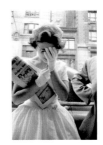

Fan in White Filled with Emotion
After Elvis enters the Hudson Theater to meet with Steve Allen and the other acts, the fan in white is so filled with his presence that her father has to comfort her.
Outside Hudson Theater, New York City, July 1, 1956
PAGE 58

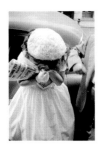

Fan in White Cries
Her emotions having overcome her, Elvis's fan breaks down and cries tears of joy.
Outside Hudson Theater, New York City, July 1, 1956
PAGE 59

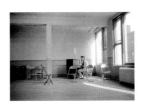

First Arrival
First to arrive at the rehearsal hall in midtown Manhattan, Elvis sits at the upright piano to sing a few gospel songs, which helps him to relax.
Steve Allen rehearsal, New York City, June 29, 1956
PAGES 60—61

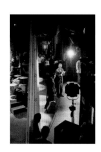

The New Elvis Presley
This is how Steve Allen
introduces Elvis after Elvis ran
into some problems on *The
Milton Berle Show* a few weeks
earlier. Elvis is now dressed in
blue tie and tux.
NBC Television, Hudson
Theater, New York City, July 1,
1956
PAGE 63

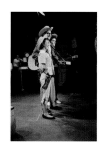

Range Round Up
Comedian, Imogene Coca, Steve
Allen, and Elvis Presley during
rehearsal of the skit "Range
Round Up," in which Elvis
plays the part of "Tumbleweed
Presley." This is his first TV
acting role.
NBC Television, Hudson
Theater, New York City,
July 1, 1956
PAGE 64

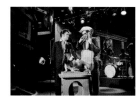

Elvis, Steve, and the Basset Hound
In rehearsal, Steve Allen, and
Elvis Presley discuss how Elvis
will sing his song "Hound Dog"
to a basset hound on a pedestal
wearing a hat.
NBC Television, Hudson
Theater, New York City,
July 1, 1956
PAGES 64–65

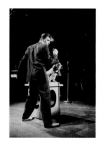

Elvis and the Hound Dog
During rehearsal, Elvis sings
the song "Hound Dog" to a live
hound dog. The dog is on the
pedestal not only to bring him
closer to Elvis's face but also to
prevent Elvis from gyrating too
much, which could cause the dog
to jump off. It is Steve's way of
containing Elvis.
NBC Television, Hudson
Theater, New York City,
July 1, 1956
PAGE 67

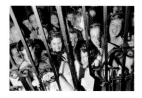

Girls Behind Bars
To maintain order at the
Hudson Theater it is decided
that the excess audience, mostly
young girls, should be barred
from the theater. They still
scream "Elvis we love you!"
NBC Television, Hudson
Theater, New York City,
July 1, 1956
PAGES 68–69

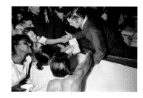

Four Desperate Fans
After his successful appearance
on *The Steve Allen Show* as
"Tumbleweed Presley," Elvis's
fans surge forward outside the
Hudson Theater hoping for
an autograph and to touch
their idol.
NBC Television, Hudson
Theater, New York City,
July 1, 1956
PAGES 70–71

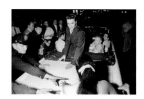

Elvis Leaves the Hudson Theater
Elvis is about to leave the
Hudson Theater and ride into
the night in his open rented
convertible.
NBC Television, Hudson
Theater, New York City,
July 1, 1956
PAGES 72–73

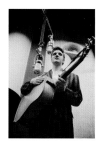

Double Mic and Back of Guitar
During the recording session at
the RCA Victor Studio I in New
York City, Elvis rehearses the
song "Don't Be Cruel" by singing
into the top mic and slapping
the back of the leather-covered
guitar with his right hand, which
is recorded on the lower mic.
New York City, July 2, 1956
PAGE 75

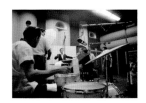

RCA Victor Studio I
Elvis Presley and his backup
band with D. J. Fontana, drums;
Scotty Moore, guitar; and Bill
Black, bass; plus the Jordanaires
vocal group rehearse the song
"Hound Dog."
RCA Victor Studio I,
New York City, July 2, 1956
PAGES 76–77

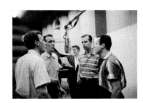

Elvis and The Jordanaires
While rehearsing "Don't Be
Cruel," Elvis gets help from his
backup singing group in the
foreground.
RCA Victor Studio I,
New York City, July 2, 1956
PAGES 78–79

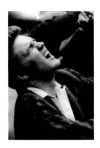

Elvis Screams
Happy with the playback during
his recording session of "Hound
Dog," Elvis screams with delight
and says, "That's it, we've got it!"
RCA Victor Studio I,
New York City, July 2, 1956
PAGE 80

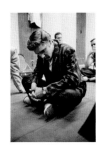

The Buddah
Elvis, in deep concentration, sits
on the floor of the recording
studio listening to a playback
of his latest take over a 14-inch
high quality speaker. Everyone
is focused on him, waiting for
his reaction. They then try a few
more takes.
RCA Victor Studio I,
New York City, July 2, 1956
PAGE 81

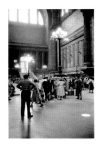

Concourse, Penn Station
Elvis and his group, comprising
Scotty Moore, Bill Black, D. J.
Fontana, Colonel Tom Parker,
his manager, Tom Diskin,
assistant manager, and Junior
Smith, Elvis's cousin and "gofer,"
are greeted by well-wishers
under the watchful eye of the
New York Railroad police.
Penn Station, New York City,
July 3, 1956
PAGE 83

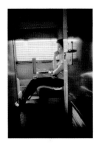

Elvis and His Portable Recorder
Having found a shaving-plug
outlet, Elvis seeks privacy on
the train heading south out
of New York to listen to
the quick acetate cuts that
he received from the sound
engineers after his recording
session the day before.
Between New York and
Chattanooga, July 3, 1956
PAGE 85

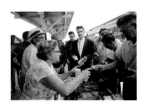

Lunchtime, Sheffield, Alabama
The Southern Railroad local
stops after noon for people
to buy some bag lunches and
snacks. Elvis waits for Junior
Smith to pay for his lunch.
Southern Railroad, July 4, 1956
PAGES 86–87

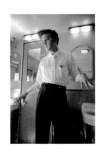

No More Paper Towels
Nearing Memphis after a 27-
hour long trip Elvis freshens up
on the train only to find after
washing his hands there are no
more paper towels. Not making
a big fuss, he just shakes his
hands dry.
Southern Railroad, July 4, 1956
PAGE 89

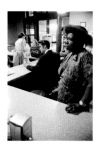

Segregated Lunch Counter
While waiting for a train to take him from Chattanooga to Memphis, a trip of some 400 miles, Elvis sits at a lunch counter to have some breakfast. The woman standing has ordered a sandwich for which she is waiting, but is not permitted to sit at the counter.
Railroad Station, Chattanooga, Tennessee, July 4, 1956
PAGE 91

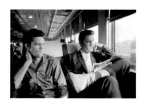

Junior Smith and Elvis Presley
During the 27-hour train ride from New York to Memphis, much of the time is spent just looking out of the window. Elvis receives comfort from his cousin Junior Smith.
Southern Railroad, July 4, 1956
PAGES 92–93

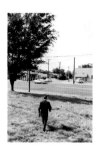

Elvis Disembarks Train
Colonel Tom Parker, Elvis's manager, gets the conductor to stop the train for a half minute so Elvis, who is anxious to get home, can jump off. He walks down a grassy knoll near White Station.
Southern Railroad, near Memphis, Tennessee, July 4, 1956
PAGE 95

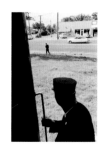

The conductor observes Elvis walking along the sidewalk near White Station, a suburb of Memphis, Tennessee.
Southern Railroad, near Memphis, Tennessee, July 4, 1956
PAGE 96 (left)

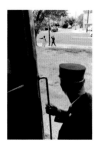

In a suburb of Memphis, Elvis asks a passerby, "Where is 1034 Audubon Drive?" the address of his home. He hopes to save an hour by not going all the way to the Memphis train station and then taking a taxi back home to see his family.
Southern Railroad, near Memphis, Tennessee, July 4, 1956
PAGE 96 (right)

Elvis, at White Station, looks back at the conductor as if to say thanks for stopping the train.
Southern Railroad, near Memphis, Tennessee, July 4, 1956
PAGE 97 (left)

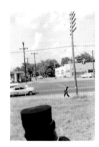

Walking alone in the small suburb of White Station, Elvis waves to the Colonel, the band members, and the conductor on the train headed into Memphis.
Southern Railroad, near Memphis, Tennessee, July 4, 1956
PAGE 97 (right)

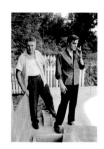

Elvis, His Father, and the Stuck Valve
Elvis and his father, Vernon, discuss the problems they are having with the swimming-pool water valve. The temporary solution to fill the deep end of the pool is to hook up a 50-foot water hose to the kitchen faucet. Elvis gets a swim in before that evening's benefit concert.
1034 Audubon Drive, Memphis Tennessee, July 4, 1956
PAGE 98

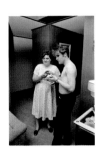

Elvis with His Mom
Elvis's mom, Gladys, shows her son a present she received from his former high-school sweetheart, who is sitting in the living room. It is a small bottle of eau de cologne. Elvis thinks it is very nice.
1034 Audubon Drive, Memphis, Tennessee, July 4, 1956
PAGE 99

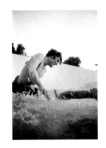

Elvis Horsing Around in the Pool
Elvis and his cousins enjoy roughhousing in the pool until Elvis shouts, "Stop!" He has forgotten to take off his wrist watch. He gives it to his mom for safekeeping. She dries it off and it continues to work. They then go back to playing.
1034 Audubon Drive, Memphis, Tennessee, July 4, 1956
PAGE 101

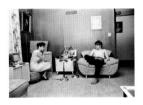

Elvis and Barbara Hearn
After having taken a shower, and still bare chested, Elvis has his former high-school sweetheart listen to the quick acetate cuts from his New York recording session.
1034 Audubon Drive, Memphis, Tennessee, July 4, 1956
PAGES 102–103

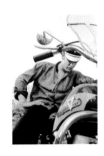

No Gas in the Tank
Wondering why the Harley won't start, Elvis finally removes the gas cap and finds to his surprise there is no gas in the tank. One of his cousins goes to the nearest gas station and brings back a jerry can half filled with gasoline. They pour it in the tank, the motor turns over, and Elvis takes a ride.
Memphis, Tennessee, July 4, 1956
PAGE 105

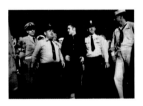

Russwood Park Escort
Having arrived for the charity concert that evening, Elvis is escorted by Memphis police and the Navy Shore Patrol into the baseball stadium.
Russwood Park, Memphis, Tennessee, July 4, 1956
PAGES 108–109

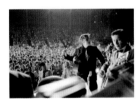

Elvis Onstage: Russwood
Playing before 14,000 fans that evening at Russwood Park with his band, Elvis receives an award and then performs onstage at the charity function with his bandmembers. He told the crowd, "Tonight you're going to see what the real Elvis is all about!" He then proceeds to gyrate and sing.
Russwood Park, Memphis, Tennessee, July 4, 1956
PAGES 110–111

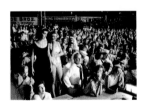

Russwood Fans
Elvis Presley fans fill up Russwood stadium to watch his performance.
Russwood Park, Memphis, Tennessee, July 4, 1956
PAGES 112–113

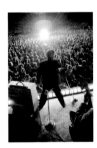

Starburst
The flash of a fan's camera illuminates the crowd in front of Elvis as he performs.
Russwood Park, Memphis, Tennessee, July 4, 1956
PAGE 115

Biographies

ALFRED WERTHEIMER

Soon after graduating from Cooper Union's School of Art in New York City and completing his two-year service as a draftee in the U.S. Army, Alfred Wertheimer began his career as a photojournalist in 1955, publishing his work in such magazines as *Life* and *Paris Match*. When RCA Victor hired the young freelancer to photograph the studio's newest recording artist in 1956, Wertheimer turned the short assignment into a unique opportunity to document Elvis Presley. Shooting intermittently between March 17 and July 4th of that year, he gathered what he now calls "The Wertheimer Collection" of Elvis photographs. With the sensibility of a reporter and the imagination of a visual artist, Wertheimer observed his subject and environment as no photographer had done before or after.

Alfred Wertheimer's photographs of Elvis Presley are a national treasure. They are a unique visual record of the most exciting and influential performer of our time. Taken in 1956, Wertheimer's photographs document Elvis Presley at the quintessential moment of his explosive appearance onto the cultural landscape. After these photos were taken, no photographer ever again had the access to Elvis that Wertheimer enjoyed. Apart from Elvis's own recordings from this period, Wertheimer's photographs are the most compelling vintage document of Elvis in 1956.

Sixty-five of Wertheimer's photographs were featured in a comprehensive exhibition at the Fondation *Cartier* for Contemporary Art in Paris entitled *Rock 'n' Roll 39—59* and published in a major monograph, *Elvis at 21: New York to Memphis* (2006). They are also featured in the Smithsonian Institution Traveling Exhibition Service tour *Elvis at 21*, beginning in January 2010, for which this book serves as a catalog.

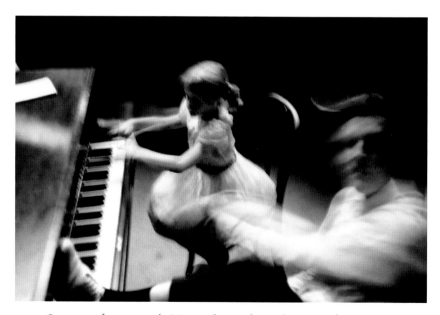

Between performances at the Mosque Theater, Elvis teaches a young fan to play the
piano in the orchestra pit. He puts his feet on the keyboard while she plays "Chopsticks"
with her little fingers. Richmond, Virginia, June 30, 1956

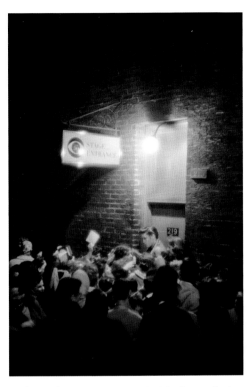

Elvis greets fans at the stage entrance to CBS Studio 50 after he appeared
on the Dorsey Brothers's *Stage Show*, New York City, March 17, 1956

CHRIS MURRAY

Chris Murray is the founder and director of Govinda Gallery in Washington, D.C. Since 1975, Murray
has organized over 200 exhibitions of many of the leading artists of our time, including Andy Warhol
in the 1970s and photographer Annie Leibovitz's first exhibition in 1984. Since that time, Govinda has
established itself as one of the most innovative contemporary galleries in the United States. Murray has
been the author or editor of over a dozen books and catalogs including *Soul Rebel: An Intimate Portrait of Bob
Marley* (2009), *John and Yoko: A New York Love Story* (2008), and *Elvis at 21: New York to Memphis* (2006).

E. WARREN PERRY, JR.,

A native of Memphis, Tennessee, E. Warren Perry, Jr. is a writer and researcher for the Smithsonian
National Portrait Gallery. He holds graduate degrees in medieval literature and creative writing from the
University of Memphis and in drama from the Catholic University of America. Warren's most recently
published work is his play *The Sitters* which can be found in the anthology *The Best of the Strawberry One Acts,
Volume IV* (2007).

AMY HENDERSON

Amy Henderson has been a cultural historian at the Smithsonian National Portrait Gallery since 1975,
specializing in 20th and 21st century music, movie, and theater history, and in the history of American
celebrity culture. Her books and exhibitions include *On the Air: Pioneers of American Broadcasting* (1988); *Red,
Hot & Blue: A Smithsonian Salute to the American Musical* (1996; the SITES traveling version of this exhibition
went to 28 venues); *Exhibiting Dilemmas: Issues of Representation at the Smithsonian* (1997); the six-part PBS
American Masters series *Broadway* (2005); "The Changing Face of Celebrity Culture" (2005); *KATE:
A Centennial Celebration* (2007–08); and *Elvis at 21* (SITES exhibition, 2009–).

Acknowledgments

I'VE ALWAYS WANTED TO BE A STORYTELLER and since my talent has never been the written word, I trained myself in the universal language of photojournalism: gathering light reflections off people's bodies and objects to be printed at a later date. Instead of telling my stories with pencil and paper, my tool of choice became the 35mm camera.

And thus we have this book, which offers a glimpse at a small sliver of the life of Elvis Presley when he was 21 years old.

I owe a debt of gratitude to the ever upbeat Chris Murray of Govinda Gallery in Washington, D.C., for connecting the dots and bringing both the Smithsonian Institution Traveling Exhibition and this book project *Elvis 1956* to a successful completion.

Thanks go to the ever energetic Lena Tabori, publisher of Welcome Books, as well as her talented staff: editor Natasha Fried, and brothers Clark and Gregory Wakabayashi, the designers through whose efforts we can attribute the excellent design and reproduction quality of this book.

Of course, there is my mom, Katy Wertheimer, who had the foresight to get the proper papers sent from my uncle Joseph and then packed up her two kids—my brother Henry and I—with assorted pots, pans, and feather bedding (plus my reluctant father Julius). She got us all safely out of Nazi Germany in 1936 to start a new life in America. Twenty years later my path crossed Elvis Presley's and these photographs were born.

There are others I would like to mention here whose talent, wisdom, or just plain niceness touched my life: Milciades Buritica, who for 14 years has helped me keep things together (along with his wife Ana for the last five years); Sonam Tsering, the best print spotter in the world; Gavin Jones from heliosphotographic.com, a super Photoshop guru who prepared all the high-res scans for this book; Georgina Galanis, who tried to keep me organized and tidy the last few years; Spiro Carras, my Greek transplant friend who has become my computer mentor; Stephen Weingrad, my attorney, who is also appreciative of fine art photography; Lynda Gregory "brick by brick," and Diane Kantzoglou "snip by snip;" Josephine Kress, whose love for animals was my introduction to cats and horses; Therese Schevtchenko, whose green thumb got me to smell the roses; Gail Buckland, who, with a great eye for the photograph, connects the past to the present; E. Warren Perry, Jr.; Amy Henderson; John Styron; and Marquette Folley—each of whom contributed to this book project or the Smithsonian Institution exhibit, or both.

Some excellent photographic printers, who over the years have printed the Wertheimer Collection of Elvis negatives, deserve appreciation: Charlie Reiche, Roland Mitichell, Ira Mandelbaum, Yetish Yetish, and Laurant Girard.

A special thanks to David Adamson and his son John Adamson for printing all of the beautiful large giclees in this Smithsonian Institution Traveling Exhibition.

Let me send greetings to Renee Wertheimer, my brother's wife, and her two children, my nieces Pamela Wertheimer and Heidi Wolhlfeld, her husband Michael, and their two children Joseph and Rachel.

It was my brother Henry, in the late 1940's, who first gave me an inexpensive, but very workable, folding bellows camera called Prontor S, which first encouraged me to take photos that others wanted to see. At Cooper Union, my alma mater, I explored my curiosity further with assorted visual media including Josef Breitenbach's class in photography.

I owe a debt to Paul Schutzer, my friend and a very talented photojournalist, with whom I shared

space at the David Linton Studio on Third Avenue in New York in 1955–56, for having introduced me to Ann Fulchino. She headed up publicity for the Pop Record Department of RCA Victor, and it was her call to me on March 12, 1956 that asked what I was doing on March 17th? She wanted me to go to CBS Television Studio 50 to document a 21-year-old singer whom RCA had recently signed. He would be performing that day and his name was Elvis Presley. My reaction was, "Elvis who?" That was the beginning of what is now a 53-year Elvis journey and it is still going strong.

Seeing a magazine photo of Carl Mydan during the Korean War, with his two black, split range finder, 35mm Nikon cameras hanging around his neck had a great influence upon me. I bought two of the same black Nikon cameras. They were the first modern professional cameras I owned, helping me achieve my new status as "the fly on the wall."

More thanks go to: Robert Pledge, who arranged and curated my Elvis exhibit in Pingyao, China in 2007; Jeffrey Smith of Contact Press Images for TCB who sold my photographs to magazines; Barbara Cox of Photokunst, and Taki and Etheleen of the Staley Wise Gallery; and special thanks to Raoul Goff, who did a superb job in producing my book, *Elvis at 21: New York to Memphis*, a masterpiece of production.

Here's a hug to Carol Butler and her great crew at Elvis Presley Enterprises: Robert Dye, Erin Spurlock, Beth Franklin, and Iris Houston who through the years have represented the Wertheimer Collection photos on commercial products, and Jonathan Seiden who makes sure all legal matters are correct.

And then there is "The Cast" who made *Elvis 1956* and rest of my Elvis collection possible:

Gladys and Vernon Presley, his parents; Minnie Mae Presley (his Grandmother); Junior Smith; Billy Smith; Bobby Smith; Steve Sholes; The Jordanaires; Scotty Moore; D. J. Fontana; Bill Black; Shorty Long; Barbara Hearn; Tommy Dorsey; Jimmy Dorsey; Steve Allen; Milton Berle; Imogene Coca; Andy Griffith; Colonel Tom Parker (EP manager); Tom Diskin; the Tux Tailor; the Ring Salesman; the Richmond Waitress; the Chattanooga Waitress; the Black Woman waiting for her sandwich; the Kiss Lady backstage at the Mosque; the Little Girl who played piano with Elvis; the two William Morris agents; the Girl in the White Dress from Long Island; the Basset Hound wearing a hat, and the 4-foot-tall stuffed Panda who spent 27 hours on the long train trip with us.

Last, but certainly not least, I would like to thank Elvis Presley, who allowed enough closeness for me to capture his light reflections. Even today, more than 50 years later, those reflections still hold up on film for those who care to see…a bit of the story of what it was like to be a 21-year-old Elvis Presley in the process of being discovered by the world.

— ALFRED WERTHEIMER

I WANT TO THANK ALFRED WERTHEIMER FOR EVERYTHING…his photographs, his encouragement, his sense of humor, his wisdom, and much more. I will always be grateful for your friendship. To my fellow curators Warren Perry and Amy Henderson, whose insightful essays for this catalog are much appreciated. To the Smithsonian Institution Traveling Exhibition Service in Washington, D.C., and especially to Marquette Folley whose enthusiasm and professionalism kept everything on track and on time. I am also appreciative of Shannon Perry for her support. To my friend and master printer David Adamson and his terrific team at Atelier Adamson: John Hughs, Wade Hornung, and Colin Loughlin. And a very special thank you to an extraordinary publisher, Lena Tabori at Welcome Books.

— CHRIS MURRAY

Colophon

Published on the occasion of the traveling exhibition *Elvis at 21: Photographs by Alfred Wertheimer*, developed collaboratively by the Smithsonian's National Portrait Gallery, the Smithsonian Institution Traveling Exhibition Service, and Govinda Gallery, and sponsored nationally by The History Channel.

The national tour of *Elvis at 21* launched at The GRAMMY Museum in Los Angeles in January 2010. For full tour details, visit www.sites.si.edu

Alfred Wertheimer's photographs are available through Govinda Gallery
1227 34th Street NW
Washington, D.C. 20007
www.govindagallery.com

Published in 2009 by Welcome Books®
An imprint of Welcome Enterprises, Inc.
6 West 18th Street, New York, NY, 10011
(212) 989-3200; fax (212) 989-3205
www.welcomebooks.com

Publisher: LENA TABORI
Editor: NATASHA TABORI FRIED
A GREG/CLARK DESIGN

Library of Congress Cataloging-in-Publication Data on file

ISBN: 978-1-59962-073-2

First Edition
10 9 8 7 6 5 4 3 2 1

PRINTED IN CHINA

For further information about this book please visit online: www.welcomebooks.com/elvis1956